Collins

ROYAL
OBSERVATORY
GREENWICH

2017 GUIDE
to the
NIGHT SKY

Storm Dunlop and Wil Tirion

Published by Collins
An imprint of HarperCollins Publishers
Westerhill Road
Bishopbriggs
Glasgow G64 2QT
www.harpercollins.co.uk

In association with
Royal Museums Greenwich, the group name for the National Maritime Museum,
Royal Observatory Greenwich, Queen's House and *Cutty Sark* 2016
www.rmg.co.uk

A catalogue record for this book is available from the British Library

ISBN 978-0-00-818663-0

10 9 8 7 6 5 4 3 2 1

Printed in China by RR Donnelley APS

If you would like to comment on any aspect of this book, please contact us at the above address or online.
e-mail: collinsmaps@harpercollins.co.uk

 facebook.com/CollinsAstronomy

@CollinsAstro

Contents

Introduction

The aim of this Guide is to help people find their way around the night sky, by showing how the stars that are visible change from month to month and by including details of various events that occur throughout the year. The objects and events described may be observed with the naked eye, or nothing more complicated than a pair of binoculars.

The conditions for observing naturally vary over the course of the year. During the summer, twilight may persist throughout the night and make it difficult to see the faintest stars. There are three recognized stages of twilight: civil twilight, when the Sun is less than 6° below the horizon; nautical twilight, when the Sun is between 6° and 12° below the horizon; and astronomical twilight, when the Sun is between 12° and 18° below the horizon. Full darkness occurs only when the Sun is more than 18° below the horizon. During nautical twilight, only the very brightest stars are visible. During astronomical twilight, the faintest stars visible to the naked eye may be seen directly overhead, but are lost at lower altitudes. As the diagram shows, during June and most of July full darkness never occurs at the latitude of London, and at Edinburgh

nautical twilight persists throughout the whole night, so at that latitude only the very brightest stars are visible.

Another factor that affects the visibility of objects is the amount of moonlight in the sky. At Full Moon, it may be very difficult to see some of the fainter stars and objects, and even when the Moon is at a smaller phase it may seriously interfere with visibility if it is near the stars or planets in which you are interested. A full lunar calendar is given for each month and may be used to see when nights are likely to be darkest and best for observation.

The celestial sphere

All the objects in the sky (including the Sun, Moon and stars) appear to lie at some indeterminate distance on a large sphere, centred on the Earth. This *celestial sphere* has various reference points and features that are related to those of the Earth. If the Earth's rotational axis is extended, for example, it points to the North and South Celestial Poles, which are thus in line with the North and South Poles on Earth. Similarly, the *celestial equator* lies in the same plane as the Earth's equator, and divides the sky into northern and

The duration of twilight throughout the year at London and Edinburgh.

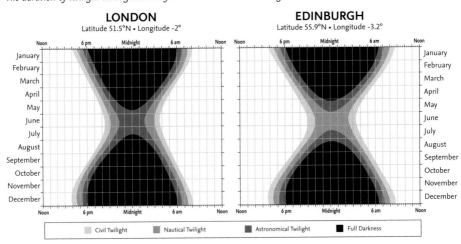

southern hemispheres. Because this Guide is written for use in Britain and Ireland, the area of the sky that it describes includes the whole of the northern celestial hemisphere and those portions of the southern that become visible at different times of the year. Stars in the far south, however, remain invisible throughout the year, and are not included.

It is useful to know some of the special terms for various parts of the sky. As seen by an observer, half of the celestial sphere is invisible, below the horizon. The point directly overhead is known as the **zenith**, and the (invisible) one below one's feet as the **nadir**. The line running from the north point on the horizon, up through the zenith and then down to the south point is the **meridian**. This is an important invisible line in the sky, because objects are highest in the sky, and thus easiest to see, when they cross the meridian in the south. Objects are said to **transit**, when they cross this line in the sky.

In this book, reference is frequently made in the text and in the diagrams to the standard compass points around the horizon. The position of any object in the sky may be described by its **altitude** (measured in degrees above the horizon), and its **azimuth** (measured in degrees from north 0°, through east 90°, south 180° and west 270°). Experienced amateurs and professional astronomers also use another system of specifying locations on the celestial sphere, but that need not concern us here, where the simpler method will suffice.

The celestial sphere appears to rotate about an invisible axis, running between the North and South Celestial Poles. The location (i.e., the altitude) of the Celestial Poles depends entirely on the observer's position on Earth or, more specifically, their latitude. The charts in this book are produced for the latitude of 50°N, so the North Celestial Pole (NCP) is 50° above the northern horizon. The fact that the NCP is fixed relative to the horizon means that all the stars within 50° of the pole are always above the horizon and may, therefore, always be seen at night, regardless of the time of year. This northern **circumpolar region** is an ideal place to begin learning the sky, and ways to identify the circumpolar stars and constellations will be described shortly.

The ecliptic and the zodiac

Another important line on the celestial sphere is the Sun's apparent path against the background stars – in reality the result

Measuring altitude and azimuth on the celestial sphere.

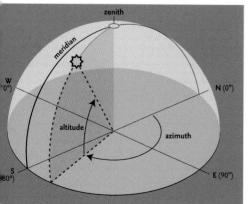

The altitude of the North Celestial Pole equals the observer's latitude.

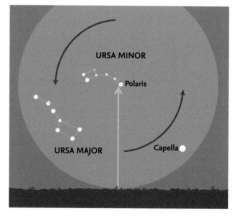

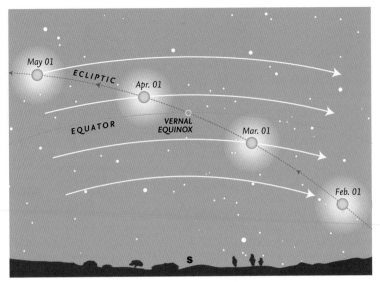

The Sun crossing the celestial equator in spring.

of the Earth's orbit around the Sun. This is known as the **ecliptic**. The point where the Sun, apparently moving along the ecliptic, crosses the celestial equator from south to north is known as the vernal (or spring) equinox, which occurs on March 20. At this time (and at the autumnal equinox, on September 22 or 23, when the Sun crosses the celestial equator from north to south) day and night are almost exactly equal in length. (There is a slight difference, but that need not concern us here.) The vernal equinox is currently located in the constellation of Pisces, and is important in astronomy because it defines the zero point for a system of celestial coordinates, which is, however, not used in this Guide.

The Moon and planets are to be found in a band of sky that extends 8° on either side of the ecliptic. This is because the orbits of the Moon and planets are inclined at various angles to the ecliptic (i.e., to the plane of the Earth's orbit). This band of sky is known as the Zodiac and, when originally devised, consisted of twelve **constellations**, all of which were considered to be exactly 30° wide. When the constellation boundaries were formally established by the International Astronomical Union in 1930, the exact extent of most constellations was altered and, nowadays, the ecliptic passes through thirteen constellations. Because of the boundary changes, the Moon and planets may actually pass through several other constellations that are adjacent to the original twelve.

The constellations

Since ancient times, the celestial sphere has been divided into various constellations, most dating back to antiquity and usually associated with certain myths or legendary people and animals. Nowadays, the boundaries of the constellations have been fixed by international agreement and their names (in Latin) are largely derived from Greek or Roman originals. Some of the names of the most prominent stars are of Greek or Roman origin, but many are derived from Arabic names. Many bright stars have no individual names and, for many years, stars were identified by terms such as 'the star in Hercules' right foot'. A more sensible scheme was introduced by the German astronomer Johannes Bayer in the early seventeenth century. Following his scheme – which is still used today – most of

the brightest stars are identified by a Greek letter followed by the genitive form of the constellation's Latin name. An example is the Pole Star, also known as Polaris and α Ursae Minoris (abbreviated α UMi). The Greek alphabet is shown on page 93 with a list of all the constellations that may be seen from latitude 50°N, together with abbreviations, their genitive forms and English names. Other naming schemes exist for fainter stars, but are not used in this book.

Asterisms

Apart from the constellations (88 of which cover the whole sky), certain groups of stars, which may form a part of a larger constellation or cross several constellations, are readily recognizable and have been given individual names. These groups are known as **asterisms**, and the most famous (and well-known) is the 'Plough', the common name for the seven brightest stars in the constellation of Ursa Major, the Great Bear. The names and details of some asterisms mentioned in this book are given in the list on page 94.

Magnitudes

The brightness of a star, planet or other body is frequently given in magnitudes (mag.). This is a mathematically defined scale where larger numbers indicate a fainter object. The scale extends beyond the zero point to negative numbers for very bright objects. (Sirius, the brightest star in the sky is mag. -1.4.) Most observers are able to see stars down to about mag. 6, under very clear skies.

The Moon

As it gradually passes across the sky from west to east in its orbit around the Earth, the Moon moves by approximately its diameter (about half a degree) in an hour. Normally, in its orbit around the Earth, the Moon passes above or below the direct line between Earth and Sun (at New Moon) or outside the area obscured by the Earth's shadow (at Full Moon).

Occasionally, however, the three bodies are more-or-less perfectly aligned to give an *eclipse*: a solar eclipse at New Moon or a lunar eclipse at Full Moon. Depending on the exact circumstances, a solar eclipse may be merely partial (when the Moon does not cover the whole of the Sun's disk); annular (when the Moon is too far from Earth in its orbit to appear large enough to hide the whole of the Sun); or total. Total and annular eclipses are visible from very restricted areas of the Earth, but partial eclipses are normally visible over a wider area.

Somewhat similarly, at a lunar eclipse, the Moon may pass through the outer zone of the Earth's shadow, the **penumbra** (in a penumbral eclipse, which is not generally perceptible to the naked eye), so that just part of the Moon is within the darkest part of the Earth's shadow, the **umbra** (in a partial eclipse); or completely within the umbra (in a total eclipse). Unlike solar eclipses, lunar eclipses are visible from large areas of the Earth.

Occasionally, as it moves across the sky, the Moon passes between the Earth and individual planets or distant stars giving rise to an **occultation**. As with solar eclipses, such occultations are visible from restricted areas of the world.

The planets

Because the planets are always moving against the background stars, they are treated in some detail in the monthly pages and information is given when they are close to other planets, the Moon or any of five bright stars that lie near the ecliptic. Such events are known as **appulses** or, more frequently, as **conjunctions**. (There are technical differences in the way these terms are defined – and should be used – in astronomy, but these need not concern us here.) The positions of the planets are shown for every month on a special chart of the ecliptic.

The term conjunction is also used when a planet is either directly behind or in front of

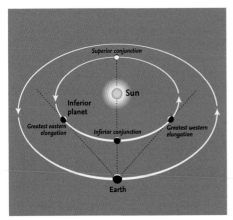

Inferior planet.

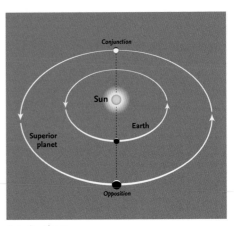

Superior planet.

the Sun, as seen from Earth. (Under normal circumstances it will then be invisible.) The conditions of most favourable visibility depend on whether the planet is one of the two known as **inferior planets** (Mercury and Venus) or one of the three **superior planets** (Mars, Jupiter and Saturn) that are covered in detail. (Some details of the fainter superior planets, Uranus and Neptune, are included in this Guide, and special charts for both are given on page 18.)

The inferior planets are most readily seen at eastern or western **elongation**, when their angular distance from the Sun is greatest. For superior planets, they are best seen at **opposition**, when they are directly opposite the Sun in the sky, and cross the meridian at local midnight.

It is often useful to be able to estimate angles on the sky, and approximate values may be obtained by holding one hand at arm's length. The various angles are shown in the diagram, together with the separations of the various stars in the Plough.

Meteors

At some time or other, nearly everyone has seen a **meteor** – a 'shooting star' – as it flashed across the sky. The particles that cause meteors – known technically as 'meteoroids' – range

in size from that of a grain of sand (or even smaller), to the size of a pea. On any night of the year there are occasional meteors, known as **sporadics**, that may travel in any direction. These occur at a rate that is normally between three and eight in an hour. Far more important, however, are **meteor showers**, which occur at fixed periods of the year, when the Earth encounters a trail of particles left behind by a comet or, very occasionally, by a minor planet (asteroid). Meteors always appear to diverge from a single point on the sky, known as the **radiant**, and the radiants of major showers are shown on the charts. Meteors that come from a circular area 8° in diameter around the radiant are classed as belonging to the particular shower. All others that do not come from that area are sporadics (or, occasionally from another shower that is active at the same time). A list of the major meteor showers is given on page 17.

Although the positions of the various shower radiants are shown on the charts, looking directly at the radiant is not the most effective way of seeing meteors. They are most likely to be noticed if one is looking about 40–45° away from the radiant position. (This is approximately two hand-spans as shown in the diagram for measuring angles.)

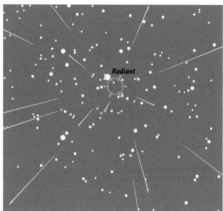

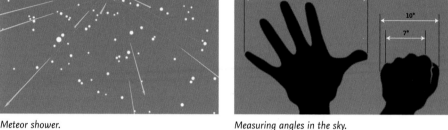

Meteor shower.

Measuring angles in the sky.

Other objects

Certain other objects may be seen with the naked eye under good conditions. Some were given names in antiquity – Praesepe is one example – but many are known by what are called 'Messier numbers', the numbers in a catalogue of nebulous objects compiled by Charles Messier in the late eighteenth century. Some, such as the Andromeda Galaxy, M31 and the Orion Nebula, M42, may be seen by the naked eye, but all those given in the list will benefit from the use of binoculars. Apart from galaxies, such as M31, which

contain thousands of millions of stars, there are also two types of cluster: open clusters, such as M45, the Pleiades, which may consist of a few dozen to some hundreds of stars; and globular clusters, such as M13 in Hercules, which are spherical concentrations of many thousands of stars. One or two gaseous nebulae, consisting of gas illuminated by stars within them, are also visible. The Orion Nebula, M42, is one, and is illuminated by the group of four stars, known as the Trapezium, which may be seen within it by using a good pair of binoculars.

Some interesting objects.

Messier / NGC	Name	Type	Constellation	Maps (months)
—	Hyades	open cluster	Taurus	Sep. – Apr.
—	Double Cluster	open cluster	Perseus	All year
—	Melotte 111 (Coma Cluster)	open cluster	Coma Berenices	Jan. – Aug.
M3	—	globular cluster	Canes Venatici	Jan. – Sep.
M4	—	globular cluster	Scorpius	May – Aug.
M8	Lagoon Nebula	gaseous nebula	Sagittarius	Jun. – Sep.
M11	Wild Duck Cluster	open cluster	Scutum	May – Oct.
M13	Hercules Cluster	globular cluster	Hercules	Feb. – Nov.
M15	—	globular cluster	Pegasus	Jun. – Dec.
M22	—	globular cluster	Sagittarius	Jun. – Sep.
M27	Dumbbell Nebula	planetary nebula	Vulpecula	May – Dec.
M31	Andromeda Galaxy	galaxy	Andromeda	All year
M35	—	open cluster	Gemini	Oct. – May
M42	Orion Nebula	gaseous nebula	Orion	Nov. – Mar.
M44	Praesepe	open cluster	Cancer	Nov. – Jun.
M45	Pleiades	open cluster	Taurus	Aug. – Apr.
M57	Ring Nebula	planetary nebula	Lyra	Apr. – Dec.
M67	—	open cluster	Cancer	Dec. – May
NGC 752	—	open cluster	Andromeda	Jul. – Mar.
NGC 3242	Ghost of Jupiter	planetary nebula	Hydra	Feb. – May

The Northern Circumpolar Constellations

The northern circumpolar stars are the key to starting to identify the constellations. For anyone in the northern hemisphere they are visible at any time of the year, and nearly everyone is familiar with the seven stars of the Plough – known as the Big Dipper in North America – an asterism that forms part of the large constellation of Ursa Major (the Great Bear).

Ursa Major

Because of the movement of the stars caused by the passage of the seasons, Ursa Major lies in different parts of the evening sky at different periods of the year. The diagram below shows its position for the four main seasons. The seven stars of the Plough remain visible throughout the year anywhere north of latitude 40°N. Even at the latitude (50°N) for which the charts in this book are drawn, many of the stars in the southern portion of the constellation of Ursa Major are hidden below the horizon for part of the year or (particularly in late summer) cannot be seen late in the night.

Polaris and Ursa Minor

The two stars **Dubhe** and **Merak** (α and β Ursae Majoris, respectively), farthest from the 'tail' are known as the 'Pointers'. A line from Merak to Dubhe, extended about five times their separation, leads to the Pole Star, **Polaris**, or α Ursae Minoris. All the stars in the northern sky appear to rotate around it. There are five main stars in the constellation of **Ursa Minor**, and the two farthest from the Pole, **Kochab** and **Pherkad**, (β and γ Ursae Minoris, respectively) are known as 'The Guards'.

Cassiopeia

On the opposite of the North Pole from Ursa Major lies **Cassiopeia**. It is highly distinctive, appearing as five stars forming a letter 'W' or 'M' depending on its orientation. Provided the sky is reasonably clear of clouds, you will nearly always be able to see either Ursa Major or Cassiopeia, and thus be able to orientate yourself on the sky.

To find Cassiopeia, start with **Alioth** (ε Ursae Majoris), the first star in the tail of the Great Bear. A line from this star extended through Polaris points directly towards **Cih** (γ Cassiopeiae), the central star of the five.

Cepheus

Although the constellation of **Cepheus** is fully circumpolar, it is not nearly as well-known as Ursa Major, Ursa Minor or Cassiopeia, partly because its stars are fainter. Its shape is rather like the gable end of a house. The line from the Pointers through Polaris, if extended, leads to **Errai** (γ Cephei) at the 'top' of the 'gable'. The brightest star, **Alderamin** (α Cephei) lies in the Milky Way region, at the 'bottom right-hand corner' of the figure.

Draco

The constellation of **Draco** consists of a quadrilateral of stars, known as the 'Head of Draco' (and also the 'Lozenge'), and a long chain of stars forming the neck and body of the dragon. To find the Head of Draco, locate the two stars **Phad** and **Megrez** (γ and δ Ursae Majoris) in the Plough, opposite the Pointers.

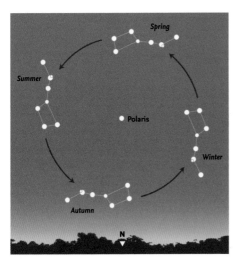

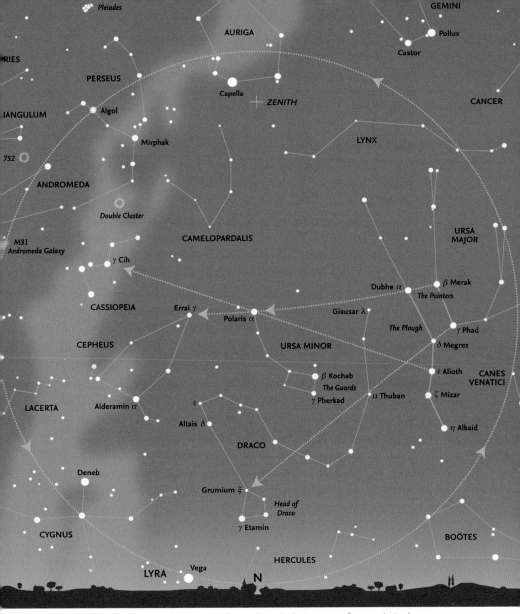

The stars and constellations inside the circle are always above the horizon, seen from our latitude.

Extend a line from Phad through Megrez by about eight times their separation, right across the sky below the Guards in Ursa Minor, ending at **Grumium** (ξ Draconis) at one corner of the quadrilateral. The brightest star, **Etamin** (γ Draconis) lies farther to the south. From the head of Draco, the constellation first runs northeast to **Altais** (δ Draconis) and ε Draconis, then doubles back southwards before winding its way through **Thuban** (α Draconis) before ending at Giausar (λ Draconis) between the Pointers and Polaris.

The Winter Constellations

The winter sky is dominated by several bright stars and distinctive constellations. The most conspicuous constellation is **Orion**, the main body of which has an hour-glass shape. It straddles the celestial equator and is thus visible from anywhere in the world. The three stars that form the 'Belt' of Orion point down towards the southeast and to **Sirius** (α Canis Majoris), the brightest star in the sky. **Mintaka** (δ Orionis), the star at the northwestern end of the Belt, farthest from Sirius, actually lies just slightly south of the celestial equator.

A line from **Bellatrix** (γ Orionis) at the 'top right-hand corner' of Orion, through **Aldebaran** (α Tauri), past the 'V' of the **Hyades** cluster, points to the distinctive cluster of bright blue stars known as the **Pleiades**, or the 'Seven Sisters'. Aldebaran is one of the five bright stars that may sometimes be occulted (hidden) by the Moon. Another line from Bellatrix, through

Betelgeuse (α Orionis), if carried right across the sky, points to the constellation of **Leo**, a prominent constellation in the spring sky.

Six bright stars in six different constellations: **Capella** (α Aurigae), **Aldebaran** (α Tauri), **Rigel** (β Orionis), **Sirius** (α Canis Majoris), **Procyon** (α Canis Minoris) and **Pollux** (β Gemini) form what is sometimes known as the 'Winter Hexagon'. Pollux is accompanied to the northwest by the slightly fainter star of **Castor** (α Gemini), the second 'Twin'.

In a counterpart to the famous 'Summer Triangle', an almost perfect equilateral triangle, the 'Winter Triangle', is formed by Betelgeuse (α Orionis), Sirius (α Canis Majoris) and Procyon (α Canis Minoris).

Several of the stars in this region of the sky show distinctive tints: Betelgeuse (α Orionis) is reddish, Aldebaran (α Tauri) is orange, and Rigel (β Orionis) is blue-white.

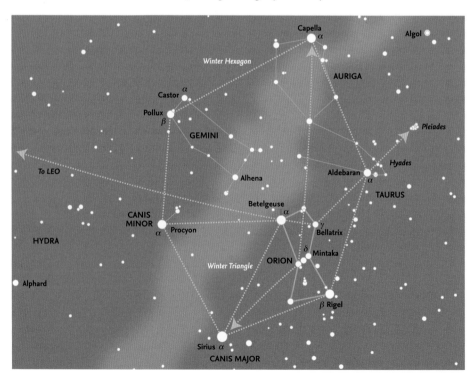

The Spring Constellations

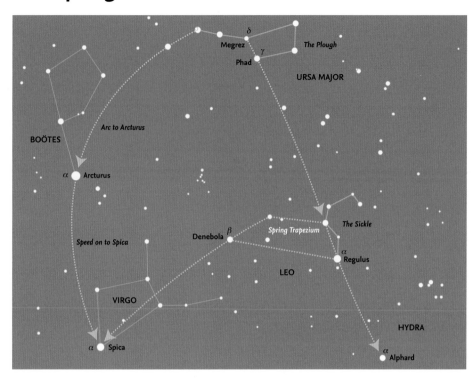

The most prominent constellation in the spring sky is the zodiacal constellation of **Leo**, and its brightest star, **Regulus** (α Leonis), which may be found by extending a line from Megrez and Phad (δ and γ Ursae Majoris, respectively) – the two stars on the opposite side of the bowl of the Plough from the Pointers – down to the southeast. Regulus forms the 'dot' of the 'backward question mark' known as 'the Sickle'. Regulus, like Aldebaran in Taurus is one of the bright stars that lie close to the ecliptic, and which are occasionally occulted by the Moon. The same line from Ursa Major to Regulus, if continued, leads to **Alphard** (α Hydrae), the brightest star in **Hydra**, the largest of the 88 constellations.

The shape formed by the body of Leo is sometimes known as the 'Spring Trapezium'. At the other end of the constellation from Regulus is **Denebola** (β Leonis), and the line forming the back of the constellation through Denebola, points to the bright star **Spica** (α Virginis) in the constellation of **Virgo**. A saying that helps to locate Spica is well-known to astronomers: 'Arc to Arcturus and then speed on to Spica.' This suggests following the arc of the tail of Ursa Major to Arcturus and then on to Spica. **Arcturus** (α Boötis) is actually the brightest star in the northern hemisphere of the sky. (Although other stars, such as Sirius, are brighter, they are all in the southern hemisphere.) Overall, the constellation of **Boötes** is sometimes described as 'kite-shaped' or 'shaped like the letter P'.

Although Spica is the brightest star in the zodiacal constellation of Virgo, the rest of the constellation is not particularly distinct, consisting of a rough quadrilateral of moderately bright stars and some fainter lines of stars extending outwards.

The Summer Constellations

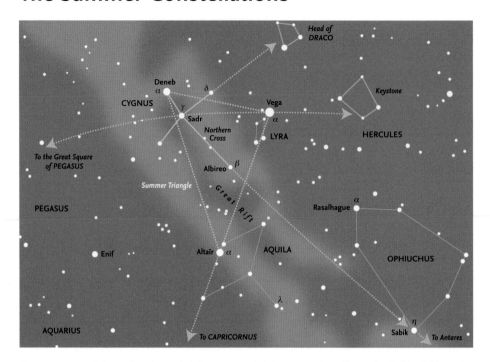

On summer nights, the three bright stars **Deneb** (α Cygni), **Vega** (α Lyrae) and **Altair** (α Aquilae) form the striking 'Summer Triangle'. The constellations of **Cygnus** (the Swan) and **Aquila** (the Eagle) represent birds 'flying' down the length of the Milky Way. This part of the Milky Way contains the **Great Rift**, an elongated dark region, where the light from distant stars is obscured by intervening dust. The dark Rift is clearly visible even to the naked eye.

The most prominent stars of Cygnus are sometimes known as the 'Northern Cross' (as a counterpart to the 'Southern Cross' – the constellation of Crux – in the southern hemisphere). The central line of Cygnus through **Albireo** (β Cygni), extended well to the southwest, points to **Sabik** (η Ophiuchi) in the large, sprawling constellation of Ophiuchus (the Serpent Bearer) and beyond to **Antares** (α Scorpii) in the constellation of **Scorpius**. Like Cepheus, the shape of Ophiuchus somewhat resembles the gable-end of a house, and the

brightest star **Rasalhague** (α Ophiuchi) is at the 'apex' of the 'gable'.

A line from the central star of Cygnus, **Sadr** (γ Cygni) through δ Cygni, in the northwestern 'wing' points towards the Head of Draco, and is another way of locating that part of the constellation. Another line from Sadr to Vega indicates the central portion, 'The Keystone', of the constellation of **Hercules**. An arc through the same stars, in the opposite direction, points towards the constellation of **Pegasus**, and more specifically to the 'Great Square of Pegasus'.

Aquila is less conspicuous than Cygnus and consists of a diamond shape of stars, representing the body and wings of the eagle, together with a rather faint star, λ Aquilae, marking the 'head'. **Lyra** (the Lyre) mainly consists of Vega (α Lyrae) and a small quadrilateral of stars to its southeast. Continuation of a line from Vega through Altair indicates the zodiacal constellation of **Capricornus**.

The Autumn Constellations

During the autumn season, the most striking feature is the 'Great Square of Pegasus', an almost perfect rectangle on the sky, forming the main body of the constellation of **Pegasus**. However, the star at the northeastern corner, **Alpheratz**, is actually α Andromedae, and part of the adjacent constellation of **Andromeda**. A line from **Scheat** (β Pegasi) at the northeastern corner of the Square, through **Matar** (η Pegasi), points in the general direction of Cygnus. A crooked line of stars leads from **Markab** (α Pegasi) through **Homam** (ζ Pegasi) and **Biham** (θ Pegasi) to **Enif** (ε Pegasi). A line from Markab through the last star in the Square, **Algenib** (γ Pegasi) points in the general direction of the five stars, including **Menkar** (α Ceti) that form the 'tail' of the constellation of **Cetus** (the Whale). A ring of seven stars lying below the southern side of the Great Square is known as 'the Circlet', part of the constellation of **Pisces** (the Fishes).

Extending the line of the western side of the Great Square towards the south leads to the isolated bright star, **Fomalhaut** (α Piscis Austrini), in the Southern Fish. Following the line of the eastern side of the Great Square towards the north leads to Cassiopeia while, in the other direction, it points towards **Deneb Kaitos** (β Ceti), which is actually the brightest star in Cetus.

Three bright stars leading northeast from Alpheratz form the main body of the constellation of **Andromeda**. Continuation of that line leads towards the constellation of **Perseus** and **Mirphak** (α Persei). Running southwards from Mirphak is a chain of stars, one of which is the famous variable star **Algol** (β Persei). Farther east, an arc of stars leads to the prominent cluster of the **Pleiades**, in the constellation of **Taurus**.

Between Andromeda and Cetus lie the two small constellations of **Triangulum** (the Triangle) and **Aries** (the Ram).

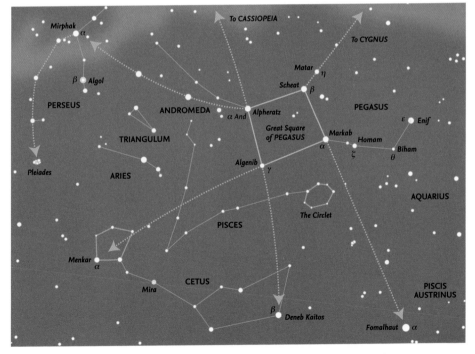

Introduction to the Month-by-Month Guide

The monthly charts

The pages devoted to each month contain a pair of charts showing the appearance of the night sky, looking north and looking south. The charts (as with all the charts in this book) are drawn for the latitude of 50°N, so observers farther north will see slightly more of the sky on the northern horizon, and slightly less on the southern. These areas are, of course, those most likely to be affected by poor observing conditions caused by haze, mist or smoke. In addition, stars close to the horizon are always dimmed by atmospheric absorption, so sometimes the faintest stars marked on the charts may not be visible.

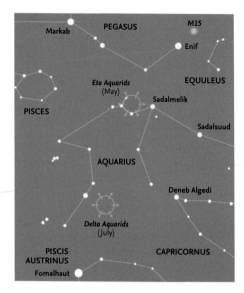

 The three times shown for each chart require a little explanation. The charts are drawn to show the appearance at 23:00 GMT for the 1st of each month. The same appearance will apply an hour earlier (22:00 GMT) on the 15th, and yet another hour earlier (21:00 GMT) at the end of the month (shown as the 1st of the following month). GMT is identical to the Universal Time (UT) used by astronomers around the world. In Europe, Summer Time is introduced in March, so the March charts apply to 23:00 GMT on March 1, 22:00 GMT on March 15, but 22:00 BST (British Summer Time) on April 1. The change back from Summer Time (in Europe) occurs in October, so the charts for that month apply to 00:00 BST for October 1, 23:00 BST for October 15, and 21:00 GMT for November 1.

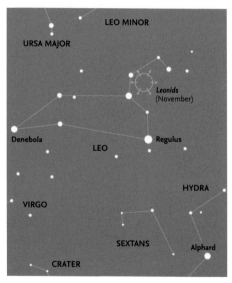

 The charts may be used for earlier or later times during the night. To observe two hours earlier, use the charts for the preceding month; for two hours later, the charts for the next month.

Meteors

Details of specific meteor showers are given in the months when they come to maximum, regardless of whether they begin or end in other months. Note that not all the respective radiants are marked on the charts for that particular month, because the radiants may be below the horizon, or lie in constellations that are not readily visible during the month of maximum. For this reason, special charts for the Eta and Delta Aquarids (May and July, respectively) and the Leonids (November)

Shower	Dates of activity 2017	Date of maximum 2017	Possible hourly rate
Quadrantids	January 1–10	January 3–4	120
April Lyrids	April 16–25	April 22–23	18
Eta Aquarids	April 19 to May 26	May 6–7	55
Alpha Capricornids	July 11 to August 10	July 27–28	5
Perseids	July 13 to August 26	August 12–13	100
Delta Aquarids	July 21 to August 23	July 28–29	< 20
Alpha Aurigids	August to October	August 28 & September 15	10
Southern Taurids	September 7 to November 19	October 23–24	< 5
Northern Taurids	October 19 to December 10	November 11–12	< 5
Orionids	October 4 to November 14	October 21–22	25
Leonids	November 5–30	November 17–18	< 15
Geminids	December 4–16	December 13–14	100+
Ursids	December 17–23	December 21–22	< 10

are given here. As explained earlier, however, meteors from such showers may still be seen, because the most effective region for seeing meteors is some 40–45° away from the radiant, and that area of sky may well be above the horizon. A table of the best meteor showers visible during the year is also given here.

The photographs
As an aid to identification – especially as some people find it difficult to relate charts to the actual stars they see in the sky – one or more photographs of constellations visible in certain specific months are included. It should be noted, however, that because of the limitations of the photographic and printing processes, and the differences between the sensitivity of different individuals to faint starlight (especially in their ability to detect different colours), and the degree to which they have become adapted to the dark, the apparent brightness of stars in the photographs will not necessarily precisely match that seen by any one observer.

The Moon calendar
The Moon calendar is largely self-explanatory. It shows the phase of the Moon for every day of the month, with the exact times (in Universal Time) of New Moon, First Quarter, Full Moon and Last Quarter. Because the times are calculated from the Moon's actual

orbital parameters, some of the times shown will, naturally, fall during daylight, but any difference is too small to affect the appearance of the Moon on that date.

The Moon
The section on the Moon includes details of any lunar or solar eclipses that may occur during the month (visible from anywhere on Earth). Similar information is given about any important occultations. Mainly, however, this section summarizes when the Moon passes close to planets or the five prominent stars close to the ecliptic. The dates when the Moon is closest to the Earth (at *perigee*) and farthest from it (at *apogee*) are shown in the monthly calendars, and only mentioned here when they are particularly significant, such as the nearest and farthest during the year.

The planets and minor planets
Brief details are given of the location, movement and brightness of the planets from Mercury to Saturn throughout the month. None of the planets can, of course, be seen when they are close to the Sun, so such periods are generally noted. All of the planets may sometimes lie on the opposite side of the Sun to the Earth (at superior conjunction), but in the case of the inferior planets, Mercury and Venus, they may also pass between the

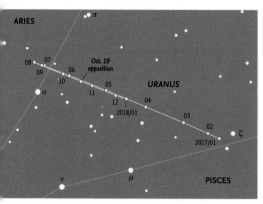

The path of Uranus in 2017. Uranus comes to opposition on October 19.

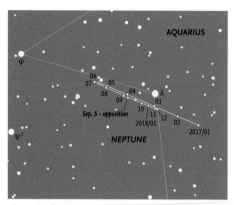

The path of Neptune in 2017. Neptune comes to opposition on September 5.

Earth and the Sun (at inferior conjunction) and are normally invisible for a longer or shorter period of time. Those two planets are normally easiest to see around either eastern or western elongation, in the evening or morning sky, respectively. Not every elongation is favourable, so although every elongation is listed, only those where observing conditions are favourable are shown in the individual diagrams of events.

The dates at which the superior planets reverse their motion (from direct motion to retrograde, and retrograde to direct) and of opposition (when a planet generally reaches its maximum brightness) are given. Some planets, especially distant Saturn, may spend most or all of the year in a single constellation. Jupiter and Saturn are normally easiest to see around opposition, which occurs every year. Mars, by contrast, moves relatively rapidly against the background stars and in some years never comes to opposition.

Uranus is not always included in the monthly details because it is generally at the limit of naked-eye visibility (magnitude 5.7–5.9), although bright enough to be visible in binoculars, or even with the naked eye under exceptionally dark skies. Its path in 2017 is shown on the special chart above. It comes to opposition on October 19 in the constellation of Pisces. New Moon occurs that day, so the planet, at magnitude 5.7, should be moderately easy to detect. It is at the same magnitude for an extended period of the year (from August to December) and should be visible when free from interference by moonlight.

Similar considerations apply to Neptune, although this is always fainter (magnitude 7.8–8.0 in 2017), but still visible in most binoculars. It reaches opposition at mag. 7.8 on September 5 in Aquarius. Full Moon occurs a day later, but Neptune should be detectable about a week before and after that date. Again, Neptune's path in 2017 and its position at opposition are shown in the chart above.

Charts for the three brightest minor planets that come to opposition in 2017 are shown in the relevant month: Vesta (mag. 6.2) on January 18, Juno (mag. 9.8) on July 2, and Pallas (mag. 8.2) on October 28.

The ecliptic charts

Although the ecliptic charts are primarily designed to show the positions and motions of the major planets, they also show the motion of the Sun during the month. The light-tinted area shows the area of the sky that is invisible during daylight, but the darker area

gives an indication of which constellations are likely to be visible at some time of the night. The closer a planet is to the border between dark and light, the more difficult it will be to see in the twilight.

The monthly calendar

For each month, a calendar shows details of significant events, including when planets are close to one another in the sky, close to the Moon, or close to any one of five bright stars that are spaced along the ecliptic. The times shown are given in Universal Time (UT), always used by astronomers throughout the year, and which is identical to Greenwich Mean Time (GMT). So during the summer months, they do not show Summer Time, which will always be one hour later than the time shown.

The diagrams of interesting events

Each month, a number of diagrams show the appearance of the sky when certain events take place. However, the exact positions of celestial objects and their separations greatly depend on the observer's position on Earth. When the Moon is one of the objects involved, because it is relatively close to Earth, there may be very significant changes from one location to another. Close approaches between planets or between a planet and a star are less affected by changes of location, which may thus be ignored.

The diagrams showing the appearance of the sky are drawn for the latitude of London, so will be approximately correct for most of Britain and Europe. However, for an observer farther north (say Edinburgh), a planet or star listed as being north of the Moon will appear even farther north, whereas one south of the Moon will appear closer to it – or may even be hidden (occulted) by it. For an observer farther south than London, there will be corresponding changes in the opposite direction: for a star or planet south of the Moon the separation will increase, and for one north of the Moon the separation will decrease. This is particularly important when occultations occur, which may be visible from one location, but not another. However, it does not apply to any occultations visible from Britain in 2017.

Ideally, details should be calculated for each individual observer, but this is obviously impractical. In fact, positions and separations are actually calculated for a theoretical observer located at the centre of the Earth.

So the details given regarding the positions of the various bodies should be used as a guide to their location. A similar situation arises with the times that are shown. These are calculated according to certain technical criteria, which need not concern us here. However, they do not necessarily indicate the exact time when two bodies are closest together. Similarly, dates and times are given, even if they fall in daylight, when the objects are likely to be completely invisible. However, such times do give an indication that the objects concerned will be in the same general area of the sky during both the preceding, and the following nights.

Key to the symbols used on the monthly star maps.

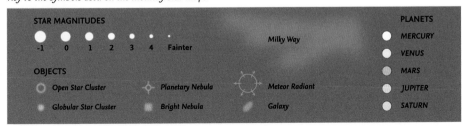

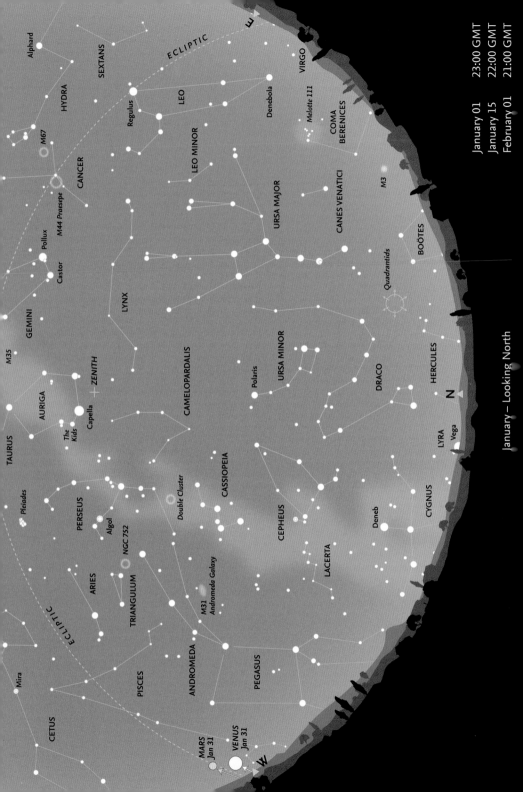

January 01 23:00 GMT
January 15 22:00 GMT
February 01 21:00 GMT

January – Looking North

January – Looking North

Most of the important circumpolar constellations are easy to see in the northern sky at this time of year. **Ursa Major** stands more-or-less vertically above the horizon in the northeast, with the zodiacal constellation of **Leo** rising in the east. To the north, the stars of **Ursa Minor** lie below **Polaris** (the Pole Star). The head of **Draco** is low on the northern horizon, but may be difficult to see unless observing conditions are good. Both **Cepheus** and **Cassiopeia** are readily visible in the northwest, and even the faint constellation of **Camelopardalis** is high enough in the sky for it to be easily visible.

Near the zenith is the constellation of **Auriga** (the Charioteer), with brilliant **Capella** (α Aurigae), directly overhead. Slightly to the west of Capella lies a small triangle of fainter stars, known as 'The Kids'. (Ancient mythological representations of Auriga show him carrying two young goats.) Together with the northernmost bright star in Taurus, β Tauri, the body of Auriga forms a large pentagon on the sky, with The Kids lying on the western side. Farther down towards the west are the constellations of **Perseus** and **Andromeda**, and the Great Square of **Pegasus** is approaching the horizon.

Meteors

One of the strongest and most consistent meteor showers of the year occurs in January: the Quadrantids, which are visible January 1–10, with maximum on January 3–4. They are brilliant, bluish and yellowish-white meteors and at maximum may even reach a rate of 120 meteors per hour. At maximum, the Moon is a waxing crescent, just before First Quarter, so there should not be too much interference from moonlight. The parent object is minor planet 2003 EH_1.

The shower is named after the former constellation **Quadrans Muralis** (the Mural Quadrant), an early form of astronomical instrument.

The Quadrantid meteor radiant is now within the northernmost part of **Boötis**, roughly half-way between θ Boötis and τ Herculis.

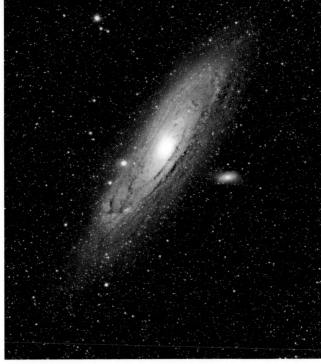

M31, the great Andromeda Galaxy, is about 220,000 light-years across, but has recently been found to be surrounded by an otherwise invisible halo of hot (10,000 to 100,000 degrees) ionized hydrogen at least 5 times that diameter, reaching half-way to our own Galaxy.

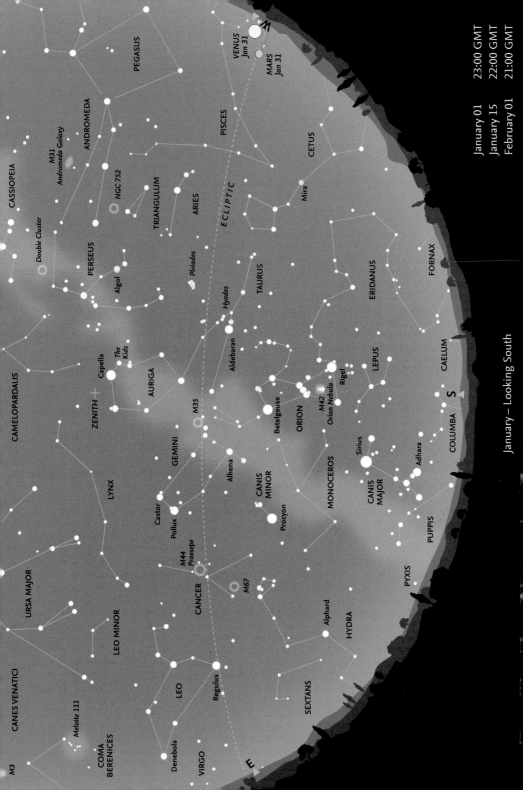

January – Looking South

January 01 23:00 GMT
January 15 22:00 GMT
February 01 21:00 GMT

January – Looking South

At this time of year the southern sky is dominated by **Orion**. This is the most prominent constellation during the winter months, when it is visible at some time during the night. (A photograph of Orion appears on page 87.) It has a highly distinctive shape, with a line of three stars that form the 'Belt'. To most observers, the bright star at the northeastern corner of the constellation, **Betelgeuse** (α Orionis), shows a reddish tinge, in contrast to the brilliant bluish-white colour of the bright star at the southwestern corner, **Rigel** (β Orionis). The three stars of the belt lie directly south of the celestial equator. A vertical line of three 'stars' forms the 'Sword' that hangs to the south of the Belt. With good viewing conditions, the central 'star' appears as a hazy spot, even to the naked eye. This is actually the Orion Nebula. Binoculars will reveal the four stars of the Trapezium, which illuminate the nebula.

The line of Orion's Belt points up to the northwest towards **Taurus** (the Bull) and below orange-tinted **Aldebaran** (α Tauri). Close to Aldebaran, there is a conspicuous 'V' of stars, pointing down to the southwest, called the **Hyades** cluster. (Despite appearances, Aldebaran is not part of the cluster.) Farther along, the same line from Orion

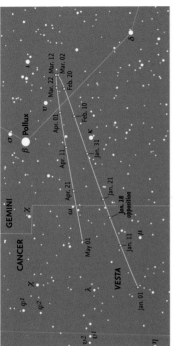

The path of minor planet (4) Vesta, which is at opposition (magnitude 6.2) on January 18. Background stars are shown down to magnitude 8.5.

passes below a bright cluster of stars, the **Pleiades**, or Seven Sisters. Even the smallest pair of binoculars reveals this cluster to be a beautiful group of bluish-white stars. The two most conspicuous of the other stars in Taurus lie directly above Orion, and form an elongated triangle with Aldebaran. The northernmost, β Tauri, was once considered to be part of the constellation of Auriga.

The Moon's phases for January

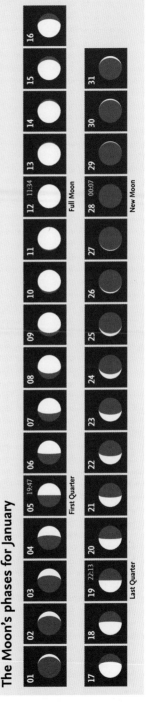

First Quarter · 05 19:47
Full Moon · 12 11:34
Last Quarter · 19 22:13
New Moon · 28 00:07

January – Moon and Planets

The Earth

The Earth reaches perihelion (the closest point to the Sun in its annual orbit) on 4 January 2017, at 14:18 Universal Time. Its distance is then 0.9833 AU (147,100,997 km).

The Moon

On January 5, the First-Quarter Moon is in *Pisces*. By January 9 it is close to *Aldebaran*. (There is an occultation, but only visible from Asia.) On January 19, at Last Quarter, is in conjunction with *Jupiter*, near *Spica* in the morning sky. The Moon is again close to Spica on January 31.

The planets

Mercury reaches greatest western elongation (magnitude -0.2) on January 19. *Venus* is at greatest eastern elongation (magnitude -4.6) after sunset on January 12. *Mars* is also an evening object, initially in *Aquarius* at magnitude 0.9, but fading slightly to magnitude 1.1 as it enters *Pisces*. *Jupiter* is moving slowly east in *Virgo* at magnitude -1.9 to -2.1 over the month. *Saturn* (magnitude 0.5), very low in the morning sky, moves very slowly eastwards in *Ophiuchus*. *Uranus* (magnitude 5.8) is in Pisces, where it remains throughout the year. Similarly, *Neptune* lies in *Aquarius* and is magnitude 7.9–8.0 in January. Minor planet *Vesta* comes to opposition just inside *Cancer* (at magnitude 6.2) on January 18.

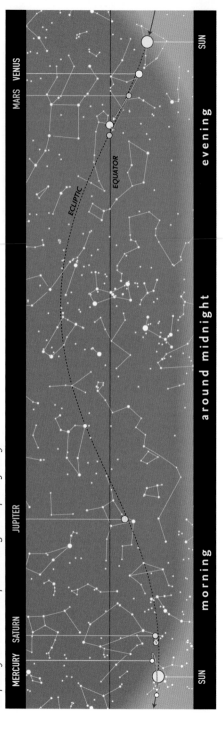

The path of the Sun and the planets along the ecliptic in January.

Calendar for January

01–10		Quadrantid meteor shower
02	09:19	Moon 1.9°N of Venus
03–04		Quadrantid shower maximum
03	06:46	Moon 0.2°N of Mars
03	04:13	Moon 0.4°N of Neptune
04	14:18	Earth at perihelion (147,100,997 km = 0.9833 AU)
05	19:47	First Quarter
06	02:08	Moon 3.3°S of Uranus
09	14:31	Moon 0.7°S of Aldebaran
10	06:01	Moon at perigee
12	11:34	Full Moon
12	13:18	Venus greatest elongation (47.1°E, mag. -4.6)
18	00:38	Vesta at opposition (mag. 6.2)
19	05:26	Moon 3°N of Jupiter
19	09:43	Mercury greatest elongation (24.1°W, mag. -0.2)
19	05:38	Moon 6.4°N of Spica
19	22:13	Last Quarter
22	00:14	Moon at apogee
23	03:53	Moon 9.9°N of Antares
24	10:18	Moon 3.6°N of Saturn
28	00:07	New Moon
30	11:25	Moon 0.2°S of Neptune
31	06:23	Jupiter 3.5°N of Spica
31	14:34	Moon 4.1°S of Venus

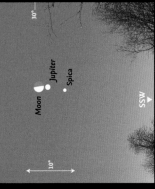

Morning 7:00

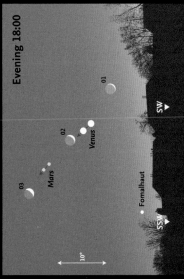

Evening 18:00

January 1-3 • *The Moon passes Venus and Mars in the evening sky. Fomalhaut is close to the horizon.*

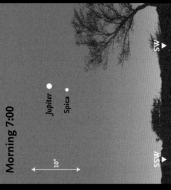

Morning 7:00

January 19 • *The Moon with Jupiter and Spica in the morning sky.*

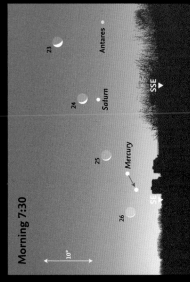

Morning 7:30

January 23–26 • *The Moon passes Antares, Saturn and Mercury, shortly before sunrise.*

January 31 • *Jupiter and Spica close together in the southwest.*

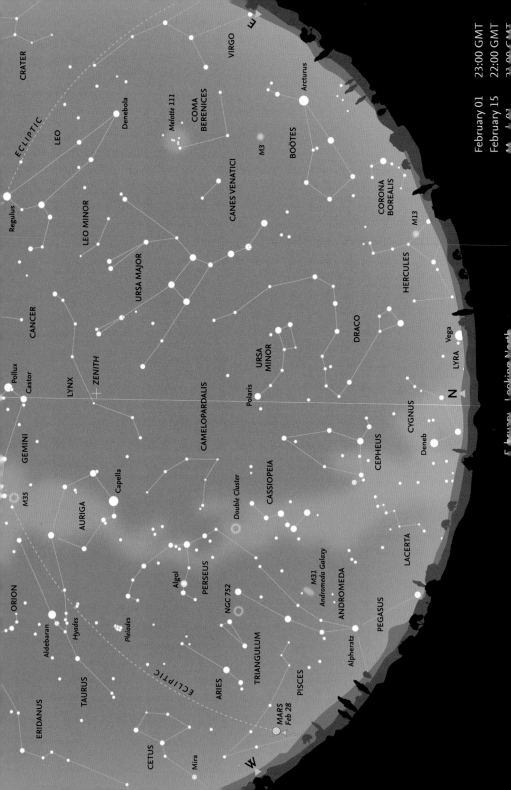

February – Looking North

Constellations and objects labelled on the chart:

CRATER
VIRGO
Arcturus
Denebola
Melotte 111
COMA BERENICES
LEO
M3
BOÖTES
Regulus
LEO MINOR
CANES VENATICI
CORONA BOREALIS
M13
HERCULES
ECLIPTIC
URSA MAJOR
CANCER
DRACO
URSA MINOR
Vega
LYRA
Pollux
Castor
LYNX
ZENITH
CAMELOPARDALIS
Polaris
N
CYGNUS
GEMINI
Capella
AURIGA
Deneb
CEPHEUS
M35
Double Cluster
CASSIOPEIA
LACERTA
ORION
Algol
PERSEUS
NGC 752
Andromeda Galaxy
M31
ANDROMEDA
PEGASUS
Aldebaran
Hyades
Pleiades
TAURUS
TRIANGULUM
Alpheratz
ERIDANUS
ARIES
PISCES
ECLIPTIC
CETUS
Mira
MARS
Feb 28
W

February – Looking North

The months of January and February are probably the best time for seeing the section of the Milky Way that runs in the northern and western sky from **Cygnus**, low on the northern horizon, through **Cassiopeia**, **Perseus** and **Auriga** and then down through **Gemini** and **Orion**. Although not as readily visible as the denser star clouds of the summer Milky Way, on a clear night so many stars may be seen that even a distinctive constellation such as **Cassiopeia** is not immediately obvious.

The head of **Draco** is now higher in the sky and easier to recognize. **Deneb**, (α Cygni), the brightest star in **Cygnus**, may just be visible almost due north at midnight, early in the month, if the sky is very clear and the horizon clear of obstacles. **Vega** (α Lyrae) in **Lyra** is so low that it is difficult to see, but may become visible later in the night. The constellation of **Boötes** – sometimes described as shaped like a kite, an ice-cream cone, or the letter 'P' – with orange-tinted **Arcturus** (α Boötis), is beginning to clear the eastern horizon. Arcturus, at magnitude -0.05, is the brightest star in the northern hemisphere. The inconspicuous constellation of **Coma Berenices** is now well above the horizon in the east. The concentration of faint stars at the northwestern corner somewhat resembles a tiny, detached portion of the Milky Way. This is Melotte 111, an open star cluster (which is sometimes called the Coma Cluster, but must not be confused with the important Coma Cluster of galaxies, Abell 1656, mentioned on page 41).

On the other side of the sky, in the northwest, most of the constellation of **Andromeda** is still easily seen, although **Alpheratz** (α Andromedae), the star that forms the northeastern corner of the Great Square of Pegasus – even though it is actually part of Andromeda – is becoming close to the horizon and more difficult to detect. High overhead, at the zenith, try to make out the very faint constellation of **Lynx**. It was introduced in 1687 by the famous astronomer Johannes Hevelius to fill the largely blank area between **Auriga**, **Gemini** and **Ursa Major**, and is reputed to be so named because one needed the eyes of a lynx to detect it.

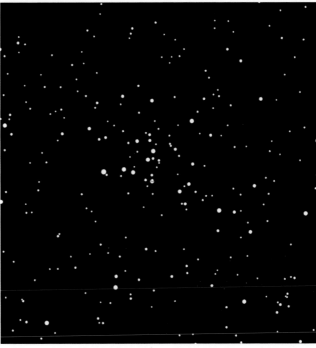

A very large, and frequently ignored, open star cluster, Melotte 111, also known as the Coma Cluster, is readily visible in the eastern sky during February.

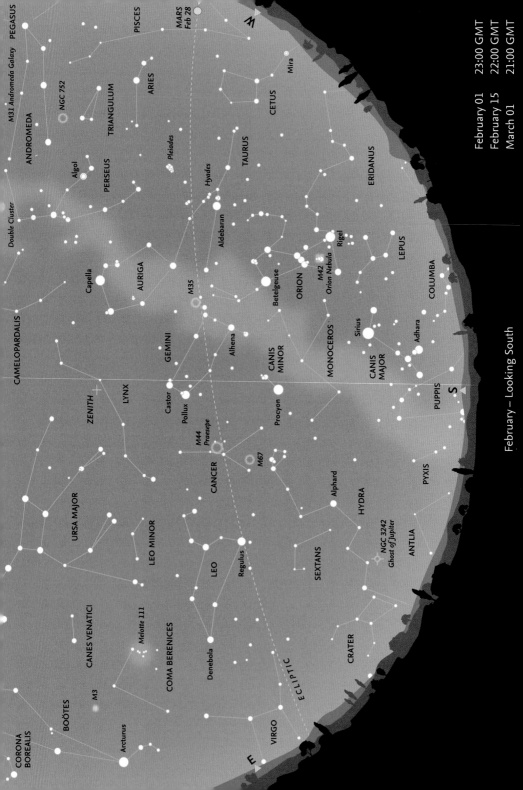

PEGASUS
PISCES
MARS Feb 28
ANDROMEDA
M31 Andromeda Galaxy
NGC 752
Double Cluster
ARIES
TRIANGULUM
Mira
CETUS
Algol
PERSEUS
Pleiades
TAURUS
Hyades
Capella
AURIGA
Aldebaran
ERIDANUS
M35
Rigel
LEPUS
CAMELOPARDALIS
Betelgeuse
ORION
M42
Orion Nebula
COLUMBA
ZENITH
LYNX
GEMINI
Alhena
Castor
Pollux
CANIS MINOR
Sirius
MONOCEROS
Adhara
CANIS MAJOR
Procyon
PUPPIS
S
URSA MAJOR
M44
Praesepe
CANCER
M67
Alphard
HYDRA
PYXIS
LEO MINOR
Melotte 111
COMA BERENICES
LEO
Regulus
SEXTANS
NGC 3242
Ghost of Jupiter
ANTLIA
CANES VENATICI
CRATER
M3
BOÖTES
Denebola
ECLIPTIC
Arcturus
CORONA
BOREALIS
VIRGO
E

February – Looking South

February – Looking South

Apart from Orion, the most prominent constellation visible this month is **Gemini**, with its two lines of stars running southwest towards Orion. Many people have difficulty in remembering which is which of the two stars **Castor** and **Pollux**. Think of them in alphabetical order: Castor (α Geminorum), the fainter star, is closer to the North Celestial Pole. Pollux (β Geminorum) is the brighter of the two, but is farther away from the Pole. Castor is remarkable because it is actually a multiple system, consisting of no less than six individual stars.

Using Orion's belt as a guide, it points down to the southeast towards **Sirius**, the brightest star in the sky (at magnitude -1.4) in the constellation of **Canis Major**, the whole of which is now clear of the southern horizon. Forming a triangle with **Betelgeuse** in Orion and **Sirius** in Canis Major is **Procyon**, the brightest star in the small constellation of **Canis Minor**. Between Canis Major and Canis Minor is the faint constellation of **Monoceros**, which actually straddles the Milky Way, which is difficult to see in this area. Directly east of Procyon is the highly distinctive asterism of six stars that form the 'head' of **Hydra**, the largest of all 88 constellations, and which trails such a long way across

the sky that it is only in mid-March around midnight that the whole constellation becomes visible.

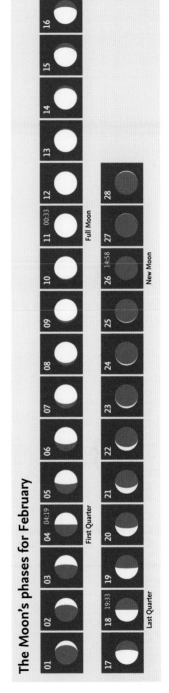

The constellation of Gemini: The two brightest stars are Castor and Pollux and may be found in the left part of the photograph.

The Moon's phases for February

February – Moon and Planets

The Moon

On February 5, as seen from London, the Moon passes extremely close to, but just misses, **Aldebaran** in **Taurus** at 22:25 UT (an occultation is visible farther south in Europe). On February 11 at Full Moon, there is a penumbral lunar eclipse, when the Moon brushes the umbra, the darker part of the shadow. That day it is near **Regulus** in **Leo**, and on February 15 in daylight it passes north of **Jupiter** in **Virgo**. On February 26 there is an annular eclipse of the Sun: the start visible over southern Chile and Argentina, mid-eclipse in the South Atlantic and the end seen from the Congo.

Occultations

Of the bright stars near the ecliptic that may be occulted by the Moon (Aldebaran, Antares, Pollux, Regulus and Spica), Aldebaran is occulted 14 times in 2017, just three of which, on February 5, November 6 and December 31 are (theoretically) visible from Britain, and Regulus twelve times, none readily seen from Britain. (There are no occultations of Antares, Pollux or Spica in 2017.)

The planets

Mercury is too close to the Sun to be readily visible. **Venus** brightens from magnitude -4.4 to -4.7 and **Mars** fades slightly from magnitude 0.9 to 1.1 over the month. Both planets move eastwards in **Pisces**. **Jupiter** (mag. -2.1 to -2.3) is in **Virgo** and begins retrograde motion on February 7. **Saturn** (mag. 0.5), initially in **Ophiuchus**, just crosses into **Sagittarius** at the end of the month. **Uranus** (mag. 5.8—5.9) is in **Pisces** while **Neptune** (mag. 8.0) is in **Aquarius**, lost in daylight.

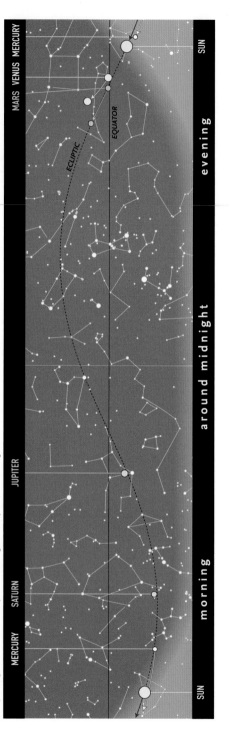

The path of the Sun and the planets along the ecliptic in February.

Calendar for February

01	01:09	Moon 2.3°S of Mars
02	08:14	Moon 3.5°S of Uranus
04	04:19	First Quarter
05	21:14	Moon 0.2°S of Aldebaran
06	14:02	Moon at perigee
11	00:33	Full Moon
11	00:44	Penumbral lunar eclipse [Europe, Middle East, Africa]
11	13:04	Moon 0.8°N of Regulus
15	14:20	Moon 6.5°N of Spica
15	14:57	Moon 2.7°N of Jupiter
18	19:33	Last Quarter
18	21:14	Moon at apogee
19	12:01	Moon 10.0°N of Antares
20	23:25	Moon 3.6°N of Saturn
26	14:53	Annular eclipse of Sun [South Atlantic Ocean]
26	14:58	New Moon
26	21:00	Moon 0.1°N of Neptune
28	19:59	Moon 10.3°S of Venus

Occultation of Aldebaran

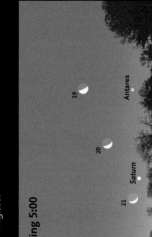

Paris 22:24:46 to 22:35:41 UT

London 22:25:23 UT

Madrid 21:57:58 to 23:01:57 UT

N

S

February 5 • Occultation of Aldebaran. It just misses from London. Times are in UT. For CET add one hour.

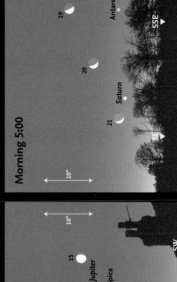

Evening 20:00

10°

Algieba

Regulus

10

11

E

ESE

February 10–11 • The Moon passes Regulus and Algieba.

Morning 6:00

25°

10°

16

15

Jupiter

Spica

SSW

SW

February 15–16 • The Moon with Jupiter and Spica in the southwest.

Morning 5:00

10°

19

20

21

Saturn

Antares

SSE

SSE

February 19–21 • The Moon passes Antares and Saturn, early in the morning.

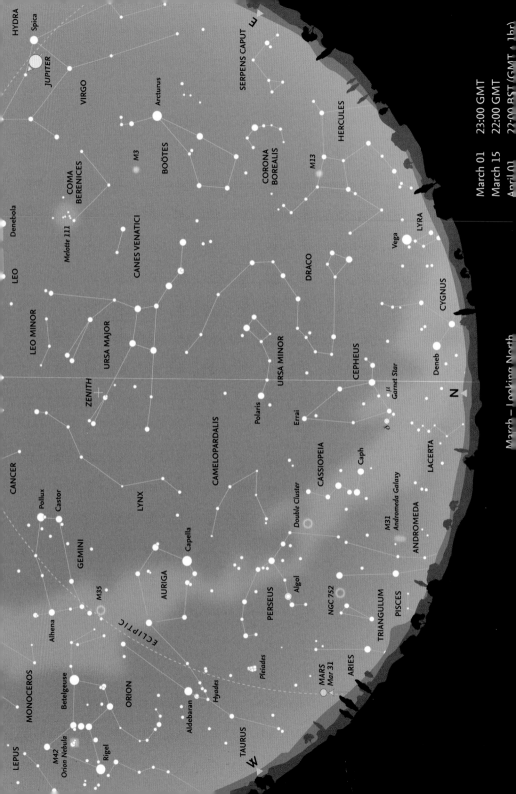

March — Looking North

March 01 23:00 GMT
March 15 22:00 GMT
April 01 22:00 BST (GMT + 1hr)

March – Looking North

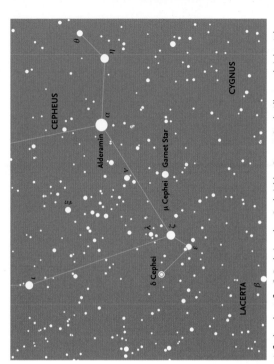

A finder chart for δ Cephei and μ Cephei (the Garnet Star). All stars brighter than magnitude 7.5 are shown.

In March, the Sun crosses the celestial equator on Monday, March 20, at the vernal equinox, when day and night are of almost exactly equal length, and the season of spring is considered to have begun. (The hours of daylight and darkness change most rapidly around the equinoxes, in March and September.) It is also in March that Summer Time begins in Europe (on Sunday, March 26) so the charts show the appearance at 23:00 GMT for March 1 and 22:00 BST for April 1. (In the USA, Daylight Saving Time is introduced two weeks earlier, on Sunday, March 12.)

Early in the month, the constellation of **Cepheus** lies almost due north, with the distinctive 'W' of **Cassiopeia** to its west. Cepheus lies across the border of the Milky Way and is often described as like the gable-end of a house or a church tower and steeple. Despite the large number of stars revealed at the base of the constellation by binoculars, one star stands out because of its deep red colour. This is Mu (μ) Cephei, also known as the **Garnet Star**, because of its striking colour. It is a truly gigantic star, a red supergiant, and one of the largest stars known. It is about 2400 times the diameter of the Sun, and if placed in the Solar System would extend beyond the orbit of Saturn. (Betelgeuse, in Orion, is also a red supergiant, but it is 'only' about 500 times the diameter of the Sun.)

Another famous, and very important star in Cepheus is **δ Cephei**, which is the prototype for the class of variable stars known as Cepheids. These giant stars show a regular variation in their luminosity, and there is a direct relationship between the period of the changes in magnitude and the stars' actual luminosity. From a knowledge of the period of any Cepheid, its actual luminosity – known as its absolute magnitude – may be derived. A comparison of its apparent magnitude on the sky and its absolute magnitude enables the star's exact distance to be determined. Once the distances to the first Cepheid variables had been established, examples in more distant galaxies provided information about the scale of the universe. Cepheid variables are the first 'rung' in the cosmic distance ladder.

Below Cepheus to the east (to the right), it may be possible to catch a glimpse of **Deneb** (α Cygni), just above the horizon. Slightly farther round towards the northeast, **Vega** (α Lyrae) is marginally higher in the sky. From southern Britain, Deneb is just far enough north to be circumpolar (although difficult to see in January and February because it is so low on the northern horizon). Vega, by contrast, farther south, is completely hidden during the depths of winter.

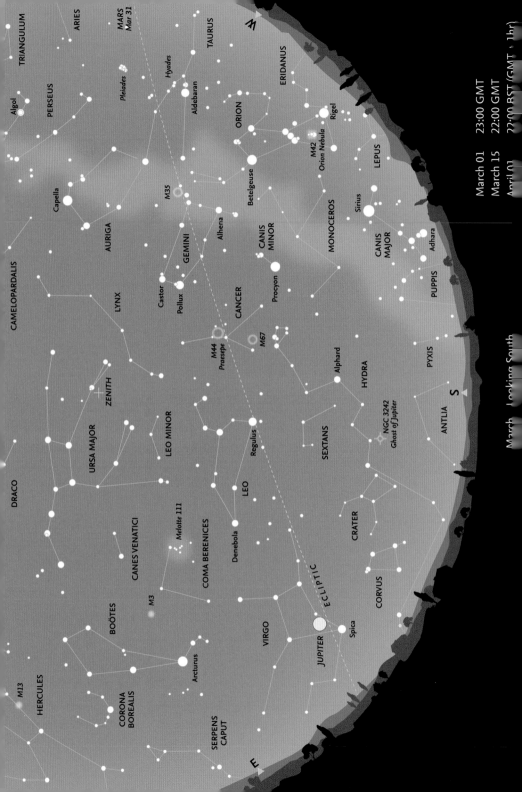

March – Looking South

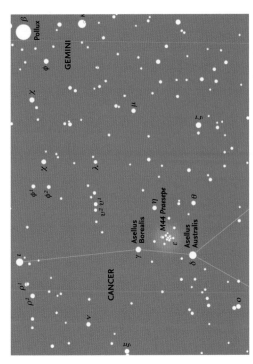

Due south at 22:00 at the beginning of the month, lying between the constellations of **Gemini** in the west and **Leo** in the east, and fairly high in the sky above the head of Hydra, is the faint, and rather undistinguished zodiacal constellation of **Cancer**. Rather like the triskelion, the symbol for the Isle of Man, it has three 'legs' radiating from the centre, where there is an open cluster, M44 or **Praesepe** ('the Manger' but also known as 'the Beehive'). On a clear night this is just a hazy spot to the naked eye, but appears in binoculars as a group of dozens of individual stars.

Also prominent in March is the constellation of **Leo**, with the 'backward question mark' (or 'Sickle') of bright stars forming the head of the mythological lion. **Regulus** (α Leonis) – the 'dot' of the 'question mark' or the handle of the sickle and the brightest star in Leo – lies very close to the ecliptic and is one of the few first-magnitude stars that may be occulted by the Moon. An occultation occurs on October 15, visible from North America, part of a series of occultations in 2017, but only on 8 December 2017 will an occultation be visible from parts of eastern Europe.

A finder chart for the open cluster M44 in Cancer. To the ancient Greeks and Romans, the two stars Asellus Borealis and Asellus Australis represented two donkeys feeding from Praesepe ('the Manger'). All stars brighter than magnitude 7.5 are shown.

The Moon's phases for March

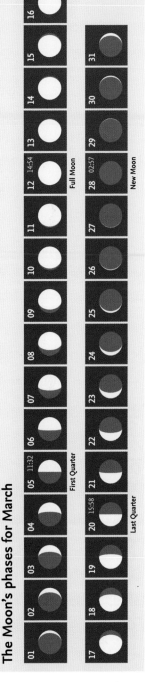

March – Moon and Planets

The Moon

On March 5, the waxing crescent Moon occults Aldebaran. This event is visible from most of North America. Early in the month it is close to both *Mars* and *Venus* low in the evening sky, returning to be close to Mars at the end of the month around New Moon. Mid-month, it passes *Jupiter* and *Spica* in Virgo around March 14, and *Saturn* (in *Sagittarius*) a few days later around March 20, at Last Quarter and the date of the vernal equinox.

The planets

Mercury is close to the Sun throughout the month, passing superior conjunction on March 7. *Venus* is also too close to the Sun to be visible in March. *Mars* is initially in *Pisces*, at magnitude 1.3, but moves eastwards into *Aries*, fading slightly to mag. 1.5 at the end of the month. *Jupiter* is retrograding slowly in *Virgo*. It remains in Virgo at magnitude -2.3 to -2.5 for the whole month. *Saturn* begins the month just inside the western border of *Sagittarius*, moving slowly eastwards at magnitude 0.5–0.4 throughout the month. *Uranus* is magnitude 5.9 in *Pisces* and *Neptune* magnitude 8.0 in *Aquarius*, too close to the Sun to be visible.

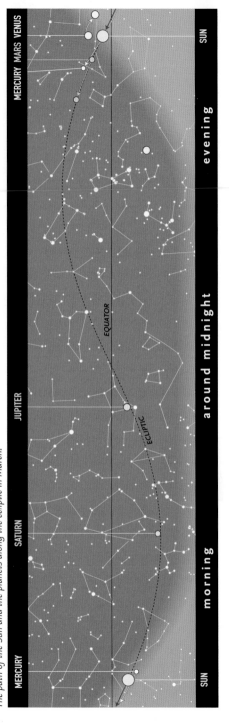

The path of the Sun and the planets along the ecliptic in March.

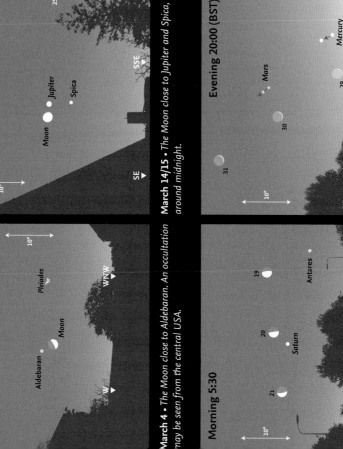

Evening 23:30

Aldebaran • Pleiades • Moon

← 10° →

W ▲ WNW ▲

March 4 • The Moon close to Aldebaran. An occultation may be seen from the central USA.

Midnight 0:00

Moon • Jupiter • Spica

← 10° →

SE ▲ SSE ▲

March 14/15 • The Moon close to Jupiter and Spica, around midnight.

Morning 5:30

19 • 20 • 21 • Saturn • Antares

← 10° →

SSE ▲ S ▲

March 19–21 • The Moon passes Antares and Saturn,

Evening 20:00 (BST)

31 • 30 • 29 • Mars • Mercury

← 10° →

WZW ▲ W ▲

March 29–31 • The thin crescent Moon passes Mercur

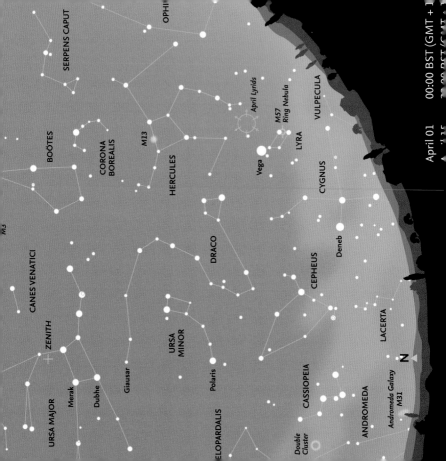

April – Looking North

Cygnus and the brighter regions of the Milky Way are now becoming visible, rising in the northeast, with the small constellation of **Lyra** and the distinctive 'Keystone' of **Hercules** above them. This asterism is very useful for locating the bright globular cluster M13 (see map on page 53). The winding constellation of **Draco** weaves its way from the quadrilateral of stars that marks its 'head', on the border with Hercules, to end at the **Giausar** (λ Draconis) between **Polaris** (α Ursae Minoris) and the 'Pointers', **Dubhe** and **Merak** (α and β Ursae Majoris, respectively). **Ursa Major** is high overhead, near the zenith. **Auriga** is still clearly seen in the northwest, but, by the end of the month, the southern portion of **Perseus** is starting to dip below the northern horizon. The very faint constellation of **Camelopardalis** lies in the northwest between Polaris and the constellations of **Auriga** and **Perseus**.

Meteors

A minor meteor shower, the **Lyrids**, peaks on April 22–23. Although the hourly rate is not very high (about 18 meteors per hour), the meteors are fast and some leave persistent trains. This year the maximum occurs when the Moon is a waning crescent, so conditions are reasonably favourable for observation. The parent object is comet C/1861 G1 (Thatcher). Another, stronger shower, the Eta Aquarids, begins to be active around April 19, and comes to maximum in May.

The constellation of Lyra is marked by the bright star Vega, which for most of Europe only dips below the northern horizon in mid-winter, with a distinctive quadrilateral of stars to its southeast.

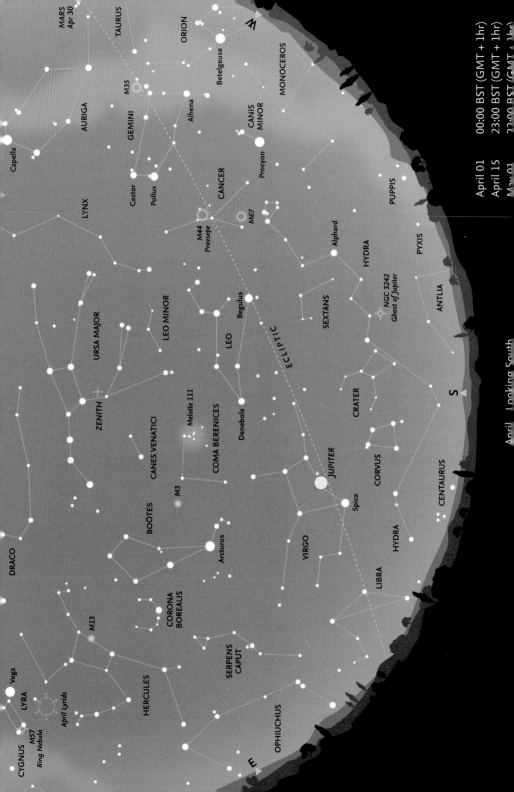

April Looking South

April 01 00:00 BST (GMT + 1hr)
April 15 23:00 BST (GMT + 1hr)
May 01 22:00 BST (GMT + 1hr)

April – Looking South

Leo is the most prominent constellation in the southern sky in April, and vaguely looks like the creature after which it is named. *Gemini*, with *Castor* and *Pollux*, remains clearly visible in the west, and *Cancer* lies between the two constellations. To the east of Leo, the whole of *Virgo*, with *Spica* (α Virginis) its brightest star, is well clear of the horizon. Below Leo and Virgo, the complete length of *Hydra* is visible, running beneath both constellations, with *Alphard* (α Hydrae) half-way between Regulus and the southwestern horizon. Farther east, the two small constellations of *Crater* and the rather brighter *Corvus* lie between Hydra and Virgo.

Boötes and *Arcturus* are prominent in the eastern sky, together with the circlet of *Corona Borealis*, framed by Boötes and the neighbouring constellation of *Hercules*. Between Leo and Boötes lies the constellation of *Coma Berenices*, notable for being the location of the open cluster Melotte 111 and the Coma Cluster of galaxies (Abell 1656). There are about 1000 galaxies in this cluster, which is located near the North Galactic Pole, where we are looking out of the plane of the Galaxy and are thus able to see deep into space. Only about ten of the brightest galaxies in the Coma Cluster are visible with the largest amateur telescopes.

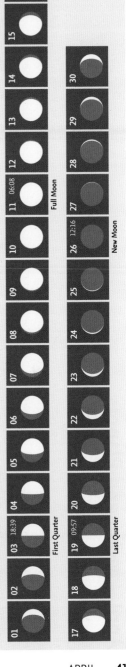

The distinctive constellation of Leo, with Regulus and 'The Sickle' on the west. Algieba (γ Leonis), north of Regulus, appearing double, is a multiple system of four stars

The Moon's phases for April

01	02	03 18:39	04	05	06	07	08	09	10	11 06:08	12	13	14	15	16
		First Quarter								Full Moon					

17	18	19 09:57	20	21	22	23	24	25	26 12:16	27	28	29	30
		Last Quarter							New Moon				

April – Moon and Planets

The Moon

On April 1, the waxing crescent Moon is close to the **Hyades** and **Aldebaran** in the western sky. (An occultation of Aldebaran is visible from the western Pacific.) At Full Moon on April 11, it is close to both **Jupiter** and **Spica** in **Virgo**. A few days later (April 15–16) it moves past **Antares** in **Scorpius** and **Saturn** in **Sagittarius**. On April 28 (after New Moon on April 26) it is again close to Aldebaran, very low in the evening sky.

The planets

Mercury reaches greatest elongation (19.0°E) on April 1, but is too low in the sunset sky to be readily visible. **Venus** is bright (-4.2 to -4.7) in April and may be glimpsed low in the east before sunrise. **Mars** moves from **Aries** to **Taurus** over the month, but is too close to the Sun to be visible. **Jupiter**, still slowly retrograding in **Virgo**, comes to opposition on April 7, fading from magnitude -2.5 to -2.4 during April. **Saturn** (mag. 0.4–0.3) is just inside **Sagittarius**. **Uranus** (magnitude 5.9) and **Neptune** (magnitude 7.9) remain in **Pisces** and **Aquarius**, respectively, both too close to the Sun to be readily visible.

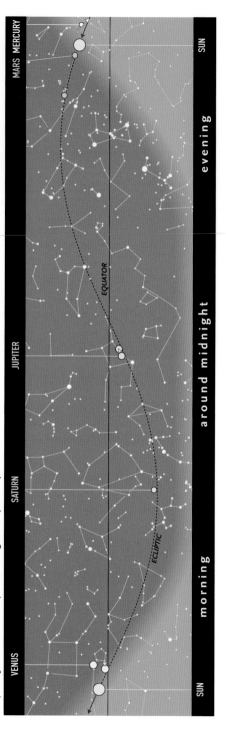

The path of the Sun and the planets along the ecliptic in April.

Calendar for April

Evening 20:00 (BST)

April 1 • Mercury and Mars with Hamal (α Arietis), after sunset.

Evening 21:00 (BST)

March 31 and April 1 • The Moon with Aldebaran and the Pleiades.

Evening 21:30 (BST)

April 20 • Mars, close to the Pleiades. Aldebaran is also nearby.

Morning 4:00 (BST)

April 10–17 • On April 11, in the early morning, the Moon is close to Jupiter and Spica. A few days later it passes Antares and Saturn.

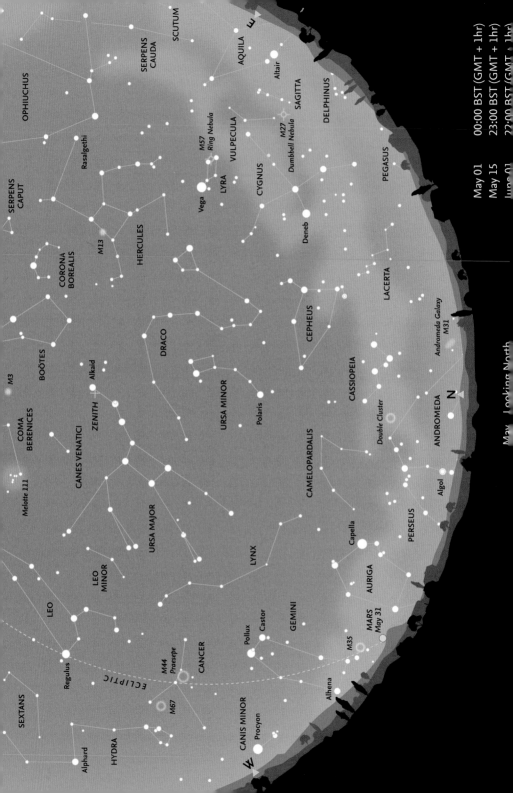

SCUTUM

SERPENS
CAUDA

OPHIUCHUS

AQUILA

E

Altair

SAGITTA

SERPENS
CAPUT

Rasalgethi

M57
Ring Nebula

VULPECULA

DELPHINUS

M13

HERCULES

LYRA

Vega

M27
Dumbbell Nebula

CYGNUS

PEGASUS

CORONA
BOREALIS

Deneb

M3

BOÖTES

DRACO

CEPHEUS

LACERTA

COMA
BERENICES

ZENITH

Alkaid

Melotte 111

CANES VENATICI

URSA MINOR

Polaris

CASSIOPEIA

Andromeda Galaxy
M31

CAMELOPARDALIS

Double Cluster

N

URSA MAJOR

ANDROMEDA

LEO
MINOR

LYNX

Algol

PERSEUS

LEO

Capella

Regulus

Castor

AURIGA

SEXTANS

M44
Praesepe

Pollux

GEMINI

MARS
May 31

ECLIPTIC

CANCER

M35

M67

Alhena

Alphard

HYDRA

CANIS MINOR

Procyon

W

May, Looking North

May 01 00:00 BST (GMT + 1hr)
May 15 23:00 BST (GMT + 1hr)
June 01 22:00 BST (GMT + 1hr)

May – Looking North

Cassiopeia is now low over the northern horizon and, to its west, the southern portions of both **Perseus** and **Auriga** are becoming difficult to observe. **Gemini**, with **Castor** and **Pollux**, is sinking towards the western horizon.

In the east, two of the stars of the 'Summer Triangle', **Vega** in **Lyra** and **Deneb** in **Cygnus**, are clearly visible, and the third, **Altair** in **Aquila**, is beginning to climb above the horizon. The sprawling constellation of **Hercules** is high in the east and the brightest globular cluster in the northern hemisphere, M13, is visible to the naked eye on the western side of the 'Keystone'.

Later in the night (and in the month) the westernmost stars of **Pegasus** begin to come into view, while the stars of **Andromeda** are skimming the northeastern horizon. High overhead, **Alkaid** (η Ursae Majoris), the last star in the 'tail' of the Great Bear, is close to the zenith, while the main body of the constellation has swung round into the western sky.

Meteors

The **Eta Aquarids** are one of the two meteor showers associated with Comet 1P/Halley (the other being the **Orionids**, in October). The Eta Aquarids are not particularly favourably placed for northern-hemisphere observers, because the radiant is near the celestial equator, near the 'Water Jar' in **Aquarius**, well below the horizon until late in the night (around dawn). However, meteors may still be seen in the eastern sky even when the radiant is below the horizon. There is a radiant map for the Eta Aquarids on page 16.

Their maximum in 2017, on May 6–7, occurs when the Moon is waxing gibbous, so conditions are not favourable for observation. Maximum hourly rate is about 55 per hour and a large proportion (about 25 per cent) of the meteors leave persistent trains.

Cygnus, sometimes known as the 'Northern Cross', depicts a swan flying down the Milky Way towards Sagittarius. The brightest star, Deneb (α Cygni), represents the tail, and Albireo (β Cygni) marks the position of the head, and may be found at bottom right of this image.

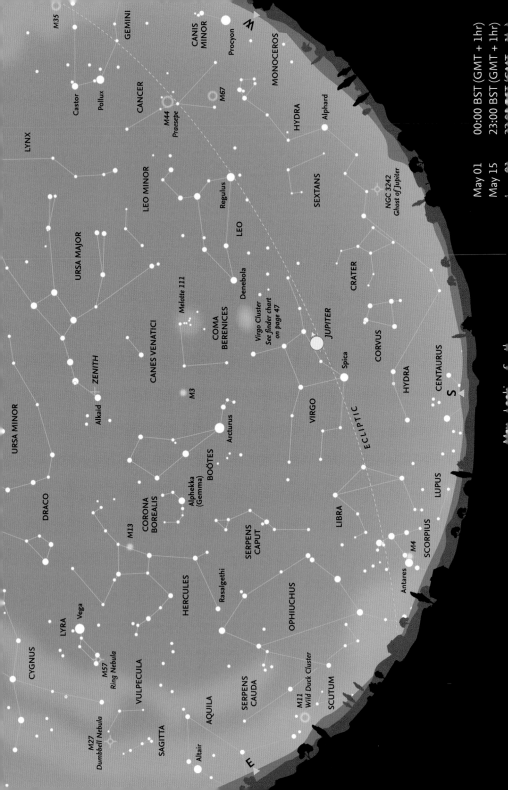

May – Looking South

Early in the night, the constellation of **Virgo**, with **Spica** (α Virginis), lies due south, with **Leo** and both **Regulus** and **Denebola** (α and β Leonis, respectively) to its west still well clear of the horizon. Later in the night, the rather faint zodiacal constellation of **Libra** becomes visible and, to its east, the ruddy star **Antares** (α Scorpii) begins to climb up over the horizon.

Virgo contains the nearest large cluster of galaxies, which is the centre of the Local Supercluster, of which the Milky Way galaxy forms part. The Virgo Cluster contains some 2000 galaxies, the brightest of which are visible in amateur telescopes.

Arcturus in **Boötes** is high in the south, with the distinctive circlet of **Corona Borealis** clearly visible to its east. The brightest star (α Coronae Borealis) is known as **Alphekka** or **Gemma**. The large constellation of **Ophiuchus** (which actually crosses the ecliptic, and is thus the 'thirteenth' zodiacal constellation) is climbing into the eastern sky. Before the constellation boundaries were formally adopted by the International Astronomical Union in 1930, the southern region of Ophiuchus was regarded as forming part of the constellation of Scorpius, which had been part of the Zodiac since antiquity.

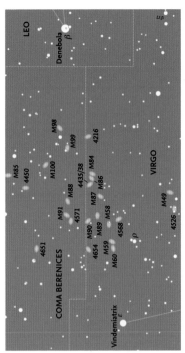

A finder chart for some of the brightest galaxies in the Virgo Cluster. All stars brighter than magnitude 8.5 are shown.

The Moon's phases for May

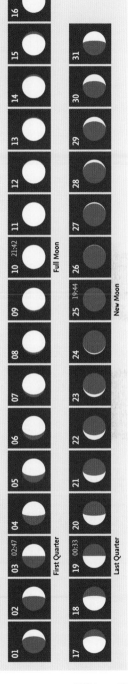

May – Moon and Planets

The Moon

The Moon passes close to **Regulus** (α Leonis) in **Leo** on May 4 and 31, just after and just before First Quarter, respectively. It passes north of **Jupiter** in **Virgo** on May 7 and **Saturn** in **Sagittarius** on May 13, three days after Full Moon. On May 22, it is close to **Venus** in the daylight sky. On May 26 it is at the closest perigee of the year (at a distance of 357,207 km).

The planets

Both **Mercury** and **Venus** are too close to the Sun to be observed in May. Early in the month, it might be possible to glimpse **Mars** low in the west at magnitude 1.6, shortly after sunset, but it then moves closer to the Sun and is lost in daylight. **Jupiter**, (at magnitude -2.4 to -2.3), continues to retrograde in **Virgo**. **Saturn** (magnitude 0.3 to 0.1) is moving eastwards slowly in **Sagittarius**. **Uranus** (initially close to **Mercury**) continues direct motion in **Pisces** at magnitude 5.9. **Neptune** is also moving slowly eastwards near 81 Aquarii, at magnitude 7.9. Both planets are lost in the dawn sky.

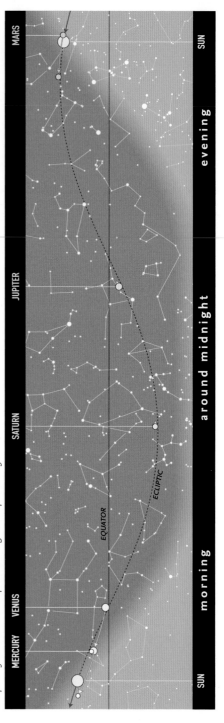

The path of the Sun and the planets along the ecliptic in May.

Calendar for May

03	02:47	First Quarter
04	09:49	Moon 0.6°S of Regulus
06–07		Eta Aquarid shower maximum
07	21:24	Moon 2.3°N of Jupiter
08	12:37	Moon 6.4°N of Spica
10	21:42	Full Moon
12	10:14	Moon 9.6°N of Antares
12	19:51	Moon at apogee
13	23:07	Moon 3.4°N of Saturn
19	00:33	Last Quarter
20	05:31	Moon 0.5°S of Neptune
22	12:32	Moon 2.4°S of Venus
23	04:40	Moon 3.9°S of Uranus
25	19:44	New Moon
26	01:21	Moon at perigee (closest of year, 357,207 km)
26	04:05	Moon 0.6°N of Aldebaran
27	01:57	Moon 5.6°S of Mars
31	16:08	Moon 0.3°S of Regulus

After midnight 2:00 (BST)

May 4–5 • The Moon with Regulus and Algieba, near the western horizon.

Early morning 3:00 (BST)

May 7 –15 • The Moon passes Jupiter and Spica in the early morning.

Morning 4:30 (BST)

May 12 –14 • The Moon with Antares and Saturn in the morning sky, before sunrise.

Morning 4:30 (BST)

May 22 • The Moon and Venus in the east, 30 minutes before sunrise.

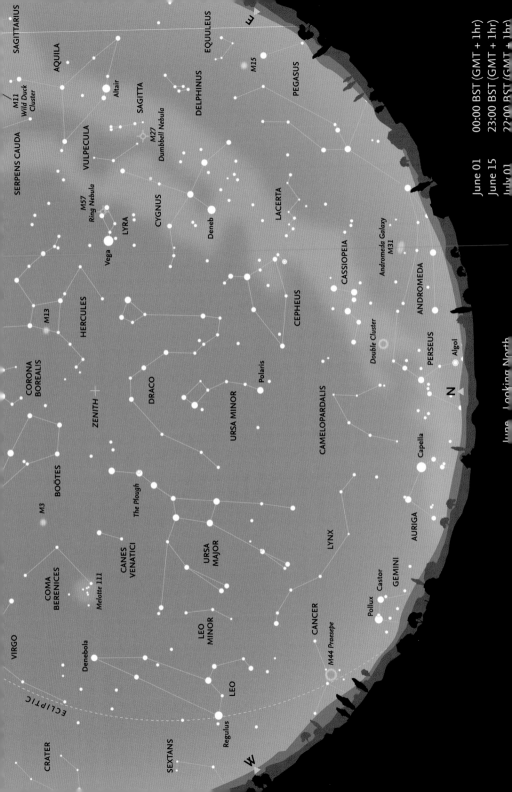

June, Looking North

June 01	00:00 BST (GMT + 1hr)
June 15	23:00 BST (GMT + 1hr)
July 01	22:00 BST (GMT + 1hr)

SAGITTARIUS

AQUILA

M11
Wild Duck
Cluster

Altair

SERPENS CAUDA

VULPECULA

SAGITTA

M27
Dumbbell Nebula

M57
Ring Nebula

LYRA

CYGNUS

Vega

Deneb

EQUULEUS

DELPHINUS

M15

PEGASUS

LACERTA

CASSIOPEIA

CEPHEUS

Andromeda Galaxy
M31

ANDROMEDA

Double Cluster

PERSEUS

Algol

N

Capella

AURIGA

Castor

Pollux

GEMINI

CANCER

M44 Praesepe

LYNX

CAMELOPARDALIS

Polaris

URSA MINOR

DRACO

HERCULES

M13

CORONA
BOREALIS

ZENITH

BOÖTES

M3

CANES
VENATICI

Melotte 111

COMA
BERENICES

VIRGO

Denebola

LEO
MINOR

LEO

Regulus

The Plough

URSA
MAJOR

SEXTANS

CRATER

ECLIPTIC

W

June – Looking North

As we approach the summer solstice (June 21), even in southern England and Ireland a form of twilight persists throughout the night and, farther north, in Scotland, the sky remains so light that most of the fainter stars and constellations are invisible. Even brighter stars, such as the seven stars making up the well-known asterism known as the **Plough** in **Ursa Major** may be difficult to detect except around local midnight, 00:00 UT (01:00 BST).

But there is one compensation during these light nights: even southern observers may be lucky enough to witness a display of noctilucent clouds (NLC). These are highly distinctive clouds shining with an electric-blue tint, observed in the sky in the direction of the North Pole. They are the highest clouds in the atmosphere, occurring at altitudes of 80–85 km, far above all other clouds. They are only visible during summer nights, for about a month or six weeks on either side of the solstice, when observers are in darkness, but the clouds themselves remain illuminated by sunlight, reaching them from the Sun, itself hidden below the northern horizon.

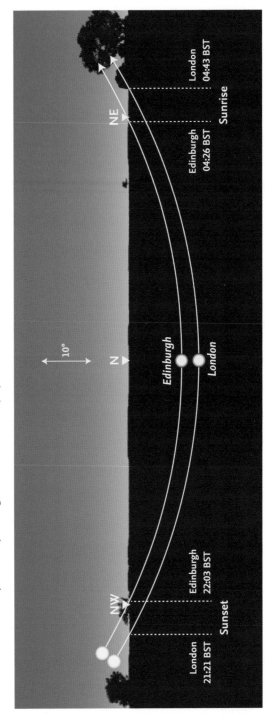

The path of the Sun on June 21 (the summer solstice) from London and Edinburgh. London does experience astronomical twilight but not full darkness, because the Sun is never more than 18° below the horizon. In Edinburgh, only nautical twilight occurs (see the twilight diagrams on page 4).

GEMINI
Pollux

CANCER

M44 *Praesepe*

LEO MINOR

LYNX

URSA MAJOR

Regulus

SEXTANS

LEO

Denebola

Melotte 111

COMA
BERENICES

CRATER

JUPITER

CANES VENATICI

CORVUS

Spica

M3

VIRGO

HYDRA

Arcturus

ECLIPTIC

URSA MINOR

ZENITH

BOÖTES

LIBRA

CENTAURUS

DRACO

CORONA
BOREALIS

M13
*See finder chart
on page 53*

SERPENS
CAPUT

S

Keystone

HERCULES

OPHIUCHUS

LUPUS

M4

Vega

Antares

SCORPIUS

LYRA

M57
Ring Nebula

SATURN

VULPECULA

SERPENS
CAUDA

M8
Lagoon Nebula

Deneb

SAGITTARIUS

M22

CYGNUS

SCUTUM

Nunki

LACERTA

SAGITTA

M11
Wild Duck Cluster

M27
Dumbbell Nebula

CAPRICORNUS

DELPHINUS

Altair

AQUILA

PEGASUS

EQUULEUS

AQUARIUS

M15

E

June, Looking South

June – Looking South

Although the persistent twilight makes observing even the southern sky difficult, the rather undistinguished constellation of **Libra** lies almost due south. The red supergiant star **Antares** – the name means the 'Rival of Mars' – in **Scorpius** is visible slightly to the east of the meridian, but the 'tail' or 'sting' remains below the horizon. Higher in the sky is the large constellation of **Ophiuchus** (the 'Serpent Bearer'), lying between the two halves of the constellation of **Serpens: Serpens Caput** ('Head of the Serpent') to the west and **Serpens Cauda** ('Tail of the Serpent') to the east. (Serpens is the only constellation to be divided into two distinct parts.) The ecliptic runs across Ophiuchus, and the Sun actually spends far more time in the constellation than it does in the 'classical' zodiacal constellation of Scorpius, a small area of which lies between Libra and Ophiuchus.

Higher in the southern sky, the three constellations of **Boötes**, **Corona Borealis** and **Hercules** are now better placed for observation than at any other time of the year.

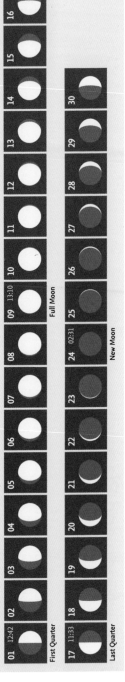

Finder chart for M13, the finest globular cluster in the northern sky. All stars down to magnitude 7.5 are shown.

The Moon's phases for June

June – Moon and Planets

The Moon

On June 3 the waxing gibbous Moon passes 2.5° north of **Jupiter**. On June 10, one day after Full Moon, it passes 3.4° north of **Saturn** in eastern **Ophiuchus**. On June 16 it is just 0.7° south of **Neptune** in the pre-dawn sky. New Moon occurs on June 24, when the Moon is actually in the northernmost extension of **Orion**. On June 28, the Moon occults **Regulus**, but the event is visible only over the Pacific. To most observers the Moon will appear to pass just south of the star.

The planets

Mercury passes superior conjunction (behind the Sun) on June 21. **Venus** reaches greatest western elongation on June 3 at magnitude -4.4. **Mars** is moving from **Taurus** into **Gemini**, but is too close to the Sun to be visible. **Jupiter**, still in **Virgo** (at mag. -2.2), continues retrograde motion until a stationary point on June 10, when it resumes direct motion, ending the month at magnitude -2.1. **Saturn** is retrograding slowly just within **Ophiuchus**, and reaches opposition on June 15 at magnitude 0.0. **Uranus** is still moving east in **Pisces** at magnitude 5.9, hidden in the dawn sky. **Neptune**, in **Aquarius**, may perhaps be seen in the pre-dawn sky. It comes to a stationary point on June 17 before starting retrograde motion, and is magnitude 7.9 throughout the month.

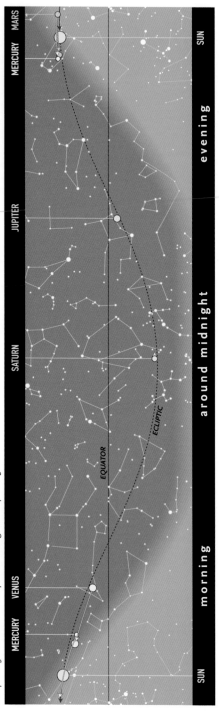

The path of the Sun and the planets along the ecliptic in June.

Calendar for June

01	12:42	First Quarter
03	12:30	Venus greatest elongation (45.9°W, mag. -4.4)
03	23:57	Moon 2.5°N of Jupiter
04	18:11	Moon 6.6°N of Spica
08	16:16	Moon 9.6°N of Antares
08	22:21	Moon at apogee
09	13:10	Full Moon
10	01:25	Moon 3.4°N of Saturn
15	10:18	Saturn at opposition (mag. 0.0)
16	12:39	Moon 0.7°S of Neptune
17	11:33	Last Quarter
19	15:35	Moon 4.1°S of Uranus
20	21:12	Moon 2.4°S of Venus
21	04:25	Summer solstice
21	14:14	Mercury at superior conjunction
22	14:45	Moon 0.5°N of Aldebaran
23	10:52	Moon at perigee
24	02:31	New Moon
24	19:53	Moon 4.4°S of Mars
28	00:26	Moon 0.1°S of Regulus

Evening 23:00 (BST)

June 3–4 • On June 3 the Moon is close to Jupiter. One day later it is almost 7 degrees north of Spica.

Evening 23:00 (BST)

June 8–10 • The Moon passes Antares and, one day later, Saturn.

Morning 4:00 (BST)

June 20 • The Moon with Venus low above the eastern horizon. The nearby Pleiades are not easy to see.

Evening 22:30 (BST)

June 27 • The Moon is close to Regulus and Algieba in the constellation of Leo.

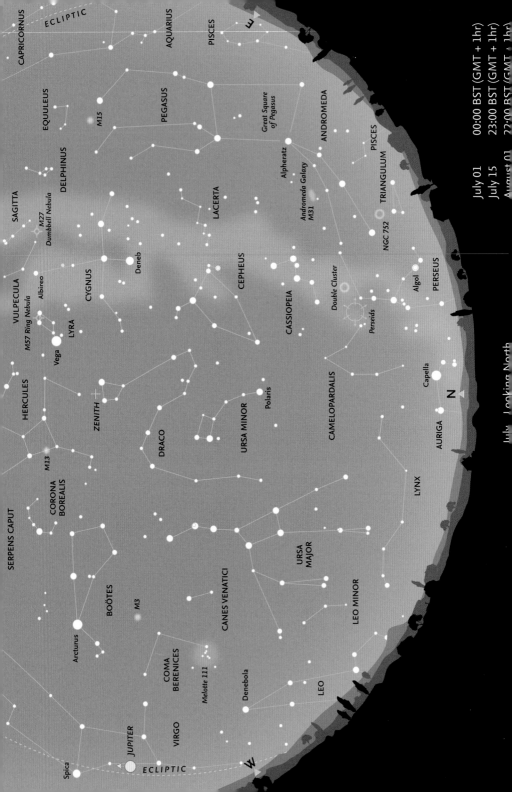

ECLIPTIC

CAPRICORNUS

AQUARIUS

PISCES

EQUULEUS

M15

PEGASUS

DELPHINUS

SAGITTA

Great Square
of Pegasus

ANDROMEDA

M27
Dumbbell Nebula

LACERTA

Alpheratz

PISCES

Andromeda Galaxy
M31

TRIANGULUM

VULPECULA

Albireo

CYGNUS

Deneb

CEPHEUS

NGC 752

M57 Ring Nebula

LYRA

Double Cluster

Algol

PERSEUS

HERCULES

Vega

CASSIOPEIA

Perseids

ZENITH

Polaris

Capella

M13

DRACO

URSA MINOR

N

AURIGA

CORONA
BOREALIS

CAMELOPARDALIS

SERPENS CAPUT

LYNX

BOÖTES

M3

URSA
MAJOR

Arcturus

CANES VENATICI

LEO MINOR

COMA
BERENICES

Melotte 111

Denebola

LEO

JUPITER

VIRGO

Spica

ECLIPTIC

W

July 01	00:00 BST (GMT + 1hr)
July 15	23:00 BST (GMT + 1hr)
August 01	22:00 BST (GMT + 1hr)

July – Looking North

As in June, light nights and the chance of observing noctilucent clouds persist throughout July, but later in the month (and particularly after midnight) some of the major constellations begin to be more easily seen. **Capella**, the brightest star in **Auriga** (most of which is too low to be visible), is skimming the northern horizon. **Cassiopeia** is clearly visible in the northeast and **Perseus**, to its south, is beginning to climb clear of the horizon. The band of the Milky Way, from Perseus through Cassiopeia towards **Cygnus**, stretches up into the northeastern sky. If the sky is dark and clear, you may be able to make out the small, faint constellation of **Lacerta**, lying across the Milky Way between Cassiopeia and Cygnus. In the east, the stars of **Pegasus** are now well clear of the horizon, with the main line of stars forming **Andromeda** roughly parallel to the horizon in the northeast. **Alpheratz** (α Andromedae) is actually the star at the northeastern corner of the **Great Square of Pegasus. Cepheus** and **Ursa Major** are on opposite sides of **Polaris** and **Ursa Minor**, in the east and west, respectively. The head of **Draco** is very close to the zenith so the whole of this winding constellation is readily seen.

Meteors

July brings increasing meteor activity, mainly because there are several minor radiants active in the constellations of **Capricornus** and **Aquarius.** Because of their location, however, observing conditions are not particularly favourable for northern-hemisphere observers, although the first shower, the **Alpha Capricornids**, active from July 11 to August 10 (peaking July 27–28), does often produce very bright fireballs. The maximum rate, however, is only about 5 per hour. The parent body is Comet 169P/NEAT. The most prominent shower is probably that of the **Delta Aquarids**, which are active from around July 21 to August 23, with a peak on July 28–29, although even then the hourly rate is unlikely to reach 20 meteors per hour. In this case, the parent body is possibly Comet 96P/Machholz. This year both shower maxima occur when there is a waxing crescent Moon, so observing conditions are quite favourable. The **Perseids**, by contrast, begin on July 13 and peak on August 12–13, when there is a waxing gibbous Moon. A chart showing the **Delta Aquarid** radiant is shown on p.16.

The New Horizons probe flew past the dwarf planet Pluto and its large satellite, Charon, on 14 July 2015. The surfaces of both bodies proved to be surprisingly varied for objects previously thought to be geologically inactive. This illustration shows some of the varied terrain on Pluto itself.

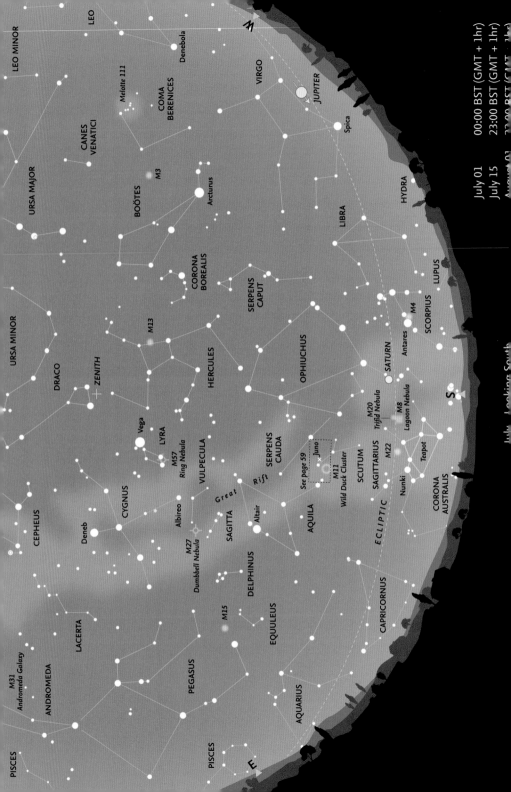

July, Looking South

July 01 00:00 BST (GMT + 1hr)
July 15 23:00 BST (GMT + 1hr)
August 01 22:00 BST (GMT + 1hr)

July – Looking South

Although part of the constellation remains hidden, this is perhaps the best time of year to see *Scorpius*, with deep red *Antares* (α Scorpii), glowing just above the southern horizon. At around midnight (UT), 01:00 BST, part of *Sagittarius*, with the distinctive asterism of the 'Teapot', and the dense star clouds of the centre of the Milky Way, are just visible in the south. With clear skies, the Great Rift – actually dust clouds that hide the more distant stars – runs down the Milky Way from Cygnus towards Sagittarius. The sprawling constellation of *Ophiuchus* lies close to the meridian for a large part of the month, separating the two halves of the constellation of *Serpens*. The western half is called *Serpens Caput* (Head of the Serpent) and the eastern part *Serpens Cauda* (Tail of the Serpent). In the east, the bright *Summer Triangle*, consisting of *Vega* in *Lyra*, *Deneb* in *Cygnus* and *Altair* in *Aquila*, begins to dominate the southern sky, as it will throughout August and into September. The small constellation of Lyra, with Vega and a distinctive quadrilateral of stars to its east and south, lies not far south of the zenith.

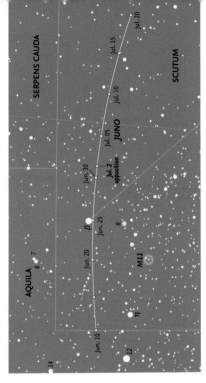

Finder chart for minor planet (3) Juno around the time of opposition on July 2. Background stars are shown down to magnitude 10.5.

The Moon's phases for July

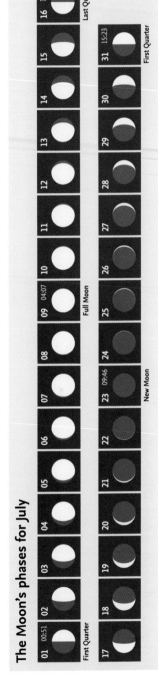

July – Moon and Planets

The Moon

On July 1, visible low in the evening sky, the First-Quarter Moon passes close to **Jupiter** and **Spica** in **Virgo**. On July 7 it is north of **Saturn** in **Ophiuchus**. Full Moon is on July 9. On July 19–20, the waning crescent is close to **Aldebaran** in **Taurus** and **Venus** in the early-morning sky. New Moon is on July 23. On July 28, the waxing-crescent Moon is again just north of **Jupiter** in **Virgo**, very low in the west.

The Earth

The Earth passes aphelion (the farthest point from the Sun in its orbit) on July 3 at 20:11 UT, when its distance is 1.01667 AU (152,092,503 km).

The planets

Mercury is initially close to the Sun but reaches greatest eastern elongation on July 30, when it is very low on the western horizon. Early in the month, **Venus** is visible at magnitude -4.2 in the pre-dawn sky, but soon becomes too close to the Sun to be seen. **Mars** is near the Sun in Gemini and thus invisible in July. **Jupiter** is moving eastwards in **Virgo**, initially at magnitude -2.1 but gradually fading to mag. -1.9. **Saturn** is slowly retrograding in **Ophiuchus** and fades slightly from magnitude 0.1 to 0.2. **Uranus** (magnitude 5.9), is moving very slowly east in **Pisces**, close to the border of **Aries**. **Neptune**, still in **Aquarius** and at magnitude 7.9–7.8, has started slow retrograde motion. On July 2, the minor planet **Juno** is at opposition in **Scutum** at magnitude 9.8.

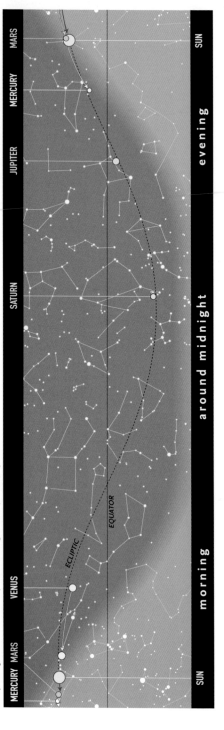

The path of the Sun and the planets along the ecliptic in July.

Calendar for July

01	00:51	First Quarter
01	07:28	Moon 2.7°N of Jupiter
02	00:22	Moon 6.8°N of Spica
02	13:12	Juno at opposition (mag. 9.8)
03	20:11	Earth at aphelion (152,092,503 km = 1.01667 AU)
05	22:24	Moon 9.7°N of Antares
06	04:28	Moon at apogee
07	03:34	Moon 3.2°N of Saturn
09	04:07	Full Moon
Jul.11–Aug.10		Alpha Capricornid meteor shower
Jul.13–Aug.26		Perseid meteor shower
13	17:49	Moon 0.9°S of Neptune
13	18:06	Venus 3.1°N of Aldebaran
16	19:26	Last Quarter
16	23:38	Moon 4.3°S of Uranus
20	00:01	Moon 0.4°N of Aldebaran
20	11:13	Moon 2.7°S of Venus
21	17:12	Moon at perigee
Jul.21–Aug.23		Delta Aquarid meteor shower
23	09:46	New Moon
23	12:53	Moon 3.1°S of Mars
25	10:37	Moon occults Regulus (Visible only Indonesia)
27	00:57	Mars in conjunction with Sun
27–28		Alpha Capricornid shower maximum
28–29		Delta Aquarid shower maximum
28	20:16	Moon 3.1°N of Jupiter
29	07:56	Moon 6.9°S of Spica
30	04:39	Mercury greatest elongation (27.2°E, mag. 0.3)
31	15:23	First Quarter

Morning 4:30 (BST)

July 4 • Venus is close to the Pleiades, before sunrise. Aldebaran is closer to the horizon.

Evening 23:00 (BST)

July 5–7 • The Moon passes Antares and Saturn low above the southern horizon.

Morning 4:30 (BST)

July 20–21 • The Moon with Aldebaran and Venus, shortly before sunrise.

Evening 22:00 (BST)

July 28–29 • The Moon passes Jupiter and Spica.

JULY 61

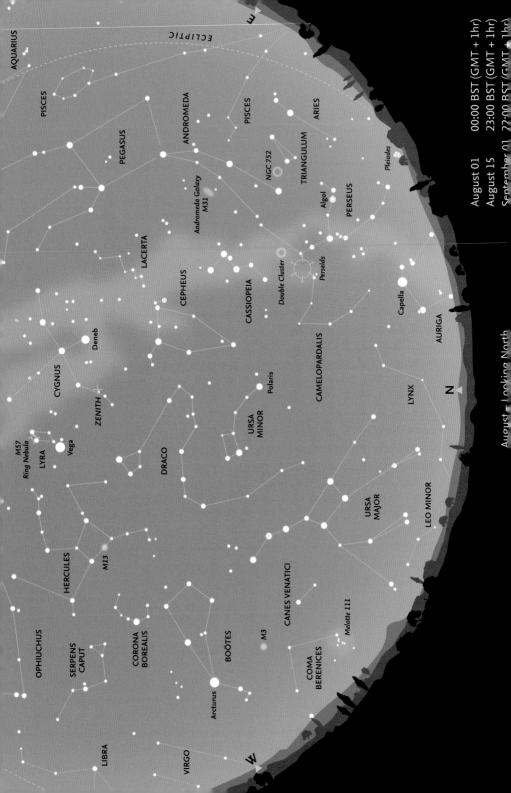

AQUARIUS

PISCES

PEGASUS

ANDROMEDA

PISCES

ARIES

ECLIPTIC

Pleiades

NGC 752

TRIANGULUM

Andromeda Galaxy
M31

Algol

PERSEUS

LACERTA

Double Cluster

CEPHEUS

Perseids

CASSIOPEIA

Deneb

CYGNUS

CAMELOPARDALIS

Capella

AURIGA

ZENITH

Polaris

URSA
MINOR

N

M57
Ring Nebula

LYRA

Vega

DRACO

LYNX

HERCULES

M13

URSA
MAJOR

LEO MINOR

CORONA
BOREALIS

CANES VENATICI

OPHIUCHUS

SERPENS
CAPUT

BOÖTES

M3

Melotte 111

COMA
BERENICES

LIBRA

VIRGO

Arcturus

W

E

August 01 00:00 BST (GMT + 1hr)
August 15 23:00 BST (GMT + 1hr)
September 01 22:00 BST (GMT + 1hr)

August – Looking North

August – Looking North

Ursa Major is now the 'right way up' in the northwest, although some of the fainter stars in the south of the constellation are difficult to see. Beyond it, *Boötes* stands almost vertically in the west, but pale orange *Arcturus* is sinking towards the horizon. Higher in the sky, both *Corona Borealis* and *Hercules* are clearly visible.

In the northeast, *Capella* is clearly seen, but most of *Auriga* still remains below the horizon. Higher in the sky, *Perseus* is gradually coming into full view and, later in the night and later in the month, the beautiful *Pleiades* cluster rises above the northeastern horizon. Between Perseus and *Polaris* lies the faint and unremarkable constellation of *Camelopardalis*.

Higher still, both *Cassiopeia* and *Cepheus* are well placed for observation, despite the fact that Cassiopeia is completely immersed in the band of the Milky Way, as is the 'base' of Cepheus. *Pegasus* and *Andromeda* are now well above the eastern horizon and, below them, the constellation of *Pisces* is climbing into view. Two of the stars in the *Summer Triangle*, *Deneb* and *Vega*, are close to the zenith high overhead.

Meteors

August is the month when one of the best meteor showers of the year occurs: the *Perseids*. This is a long shower, generally beginning about July 13 and continuing until around August 26, with a maximum in 2017 on August 12–13, when the rate may reach as high as 100 meteors per hour (and on rare occasions, even higher). In 2017, maximum is between Full Moon and Last Quarter, so conditions are not particularly favourable. The Perseids are debris from Comet 109P/Swift-Tuttle (the Great Comet of 1862). Perseid meteors are fast and many of the brighter ones leave persistent trains. Some bright fireballs also occur during the shower.

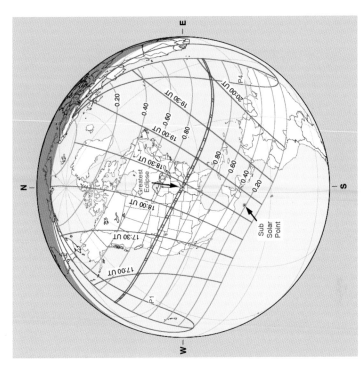

The solar eclipse of August 21. The path of totality enters the United States over Oregon and leaves from South Carolina. Times are in UT and do not show local, zone time. Greatest eclipse is north-west of Nashville, Tennessee at 1:21 p.m. Central Daylight Time.

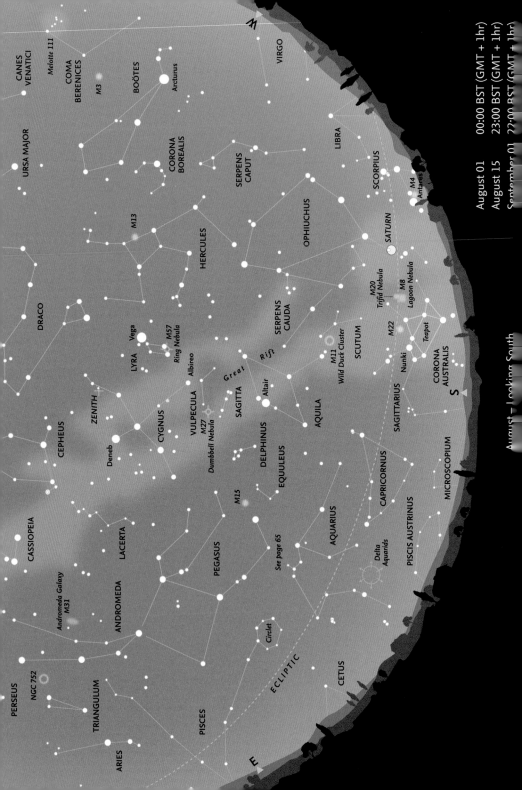

August 01 00:00 BST (GMT + 1hr)
August 15 23:00 BST (GMT + 1hr)
September 01 22:00 BST (GMT + 1hr)

August – Looking South

August – Looking South

The whole stretch of the summer Milky Way stretches across the sky in the south, from **Cygnus**, high in the sky near the zenith, past **Aquila**, with bright **Altair** (α Aquilae), to part of the constellation of **Sagittarius** close to the horizon, where the pattern of stars known as the 'Teapot' may be just visible. Between **Albireo** (β Cygni) and Altair lie the two small constellations of **Vulpecula** and **Sagitta**, with the latter easier to distinguish (because of its shape) from the clouds of the Milky Way. Between Sagitta and **Pegasus** to the east lie the highly distinctive five stars that form the tiny constellation of **Delphinus** (again, one of the few constellations that actually bear some resemblance to the creatures after which they are named). Below Aquila, mainly in the star clouds of the Milky Way, lies **Scutum**, most famous for the bright open cluster, M11 or the 'Wild Duck Cluster', readily visible in binoculars. To the southeast of Aquila lie the two zodiacal constellations of **Capricornus** and **Aquarius**

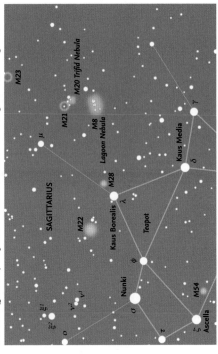

A finder chart for the gaseous nebulae M8 (the Lagoon Nebula) and M20 (the Trifid Nebula) and the globular cluster M22, all in Sagittarius. Clusters M21 & M23 (open) and M28 (globular) are faint. The chart shows all stars brighter than magnitude 7.5.

The Moon's phases for August

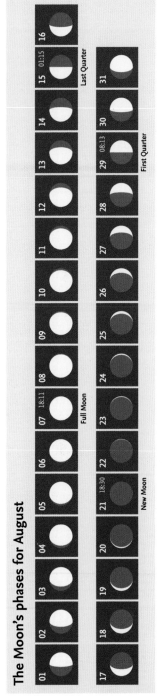

August – Moon and Planets

The Moon

The Moon is close to **Saturn** in **Ophiuchus** on August 3 and again on August 30. On August 7, at Full Moon, there is a partial solar eclipse (only a small portion of the Sun being covered), visible from East Africa, Asia and Australia. On August 16, the Moon passes very close to **Aldebaran**. (There is an occultation that begins just off the East Coast of the United States, visible only from the Atlantic Ocean.) There is a total solar eclipse on August 21, with the line of totality crossing the United States from Oregon to South Carolina, with a partial eclipse visible from Canada to the Caribbean.

The planets

Mercury is too close to the Sun to be visible in August and passes inferior conjunction on August 26. On August 20, **Venus** (at magnitude -3.9) is close to **Pollux** in **Gemini** in the early-morning sky, but then moves towards the Sun. **Mars** moves from **Cancer** into **Leo**, but is close to the Sun and invisible. **Jupiter** is moving eastwards towards **Spica** in **Virgo** and may be glimpsed, low in the west, early in the month. **Saturn** (magnitude 0.2–0.4) is in **Ophiuchus** throughout August. **Uranus** (magnitude 5.8–5.7), in **Pisces**, reaches a stationary point close to **Aries** on August 3 and then begins retrograde motion. **Neptune** (magnitude 7.8) is farther west, in **Aquarius**.

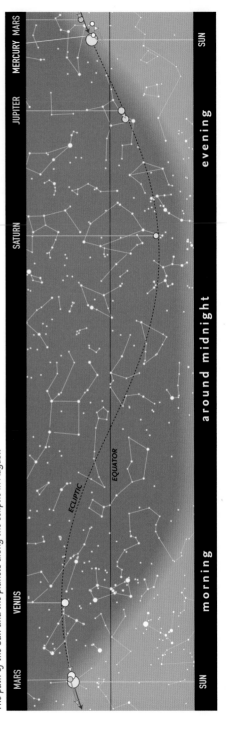

The path of the Sun and the planets along the ecliptic in August.

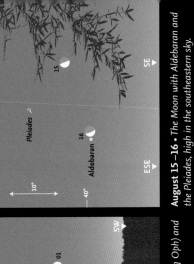

Evening 23:00 (BST)

August 1–3 • The Moon passes Antares, Sabik (η Oph) and Saturn.

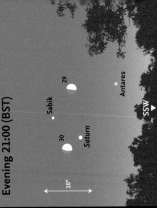

Morning 5:00 (BST)

August 15–16 • The Moon with Aldebaran and the Pleiades, high in the southeastern sky.

Morning 5:30 (BST)

August 18–20 • The Moon passes Alhena and Venus shortly before sunrise. Castor, Pollux and Procyon are also nearby.

Evening 21:00 (BST)

August 29–30 • The Moon, again in the company of Antares, Sabik and Saturn.

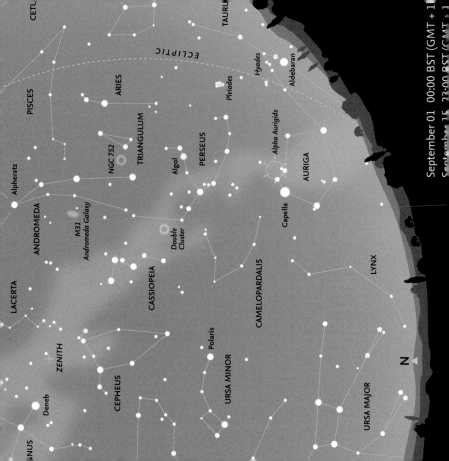

September 01 00:00 BST (GMT + 1)
September 15 23:00 BST (GMT + 1)

September – Looking North

Ursa Major is now low in the north and to the northwest **Arcturus** and much of **Boötes** sink below the horizon later in the night and later in the month. In the northeast **Auriga** is beginning to climb higher in the sky. Later in the month, **Taurus**, with orange **Aldebaran** (α Tauri), and even **Gemini**, with **Castor** and **Pollux**, become visible in the east and northeast. Due east, **Andromeda** is now clearly visible, with the small constellations of **Triangulum** and **Aries** (the latter a zodiacal constellation) directly below it. Practically the whole of the Milky Way is visible, arching across the sky, both in the north and in the south. It is not particularly clear in Auriga, or even **Perseus**, but in **Cassiopeia** and on towards **Cygnus** the clouds of stars become easier to see. **Cepheus** is 'upside-down' near the zenith, and the head of **Draco** and **Hercules** beyond it are well placed for observation.

Meteors

After the major Perseid shower in August, there is very little shower activity in September. One minor, but very extended, shower, known as the **Alpha Aurigids**, actually has two peaks of activity. The first was on August 28 but the primary peak occurs on September 15. At either of the maxima, however, the hourly rate hardly reaches 10 meteors per hour, although the meteors are bright and relatively easy to photograph. Activity from this shower also extends into October. The **Southern Taurid** shower begins this month and, although rates are low, often produces very bright fireballs. As a slight compensation for the lack of activity, however, in September the number of sporadic meteors reaches its highest rate at any time during the year.

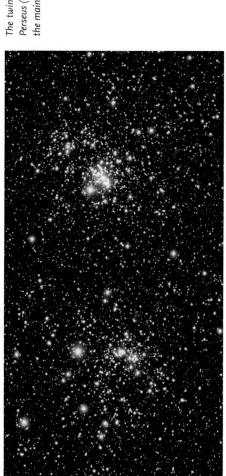

The twin open clusters, known as the Double Cluster, in Perseus (more formally called **h** *and* **χ Persei***) are close to the main portion of the Milky Way.*

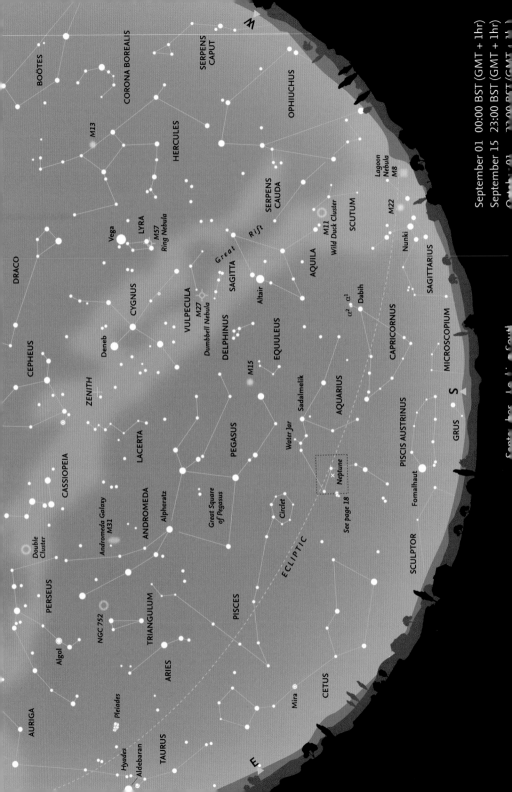

E

N

S

ZENITH

BOÖTES

CORONA BOREALIS

SERPENS CAPUT

OPHIUCHUS

M13

HERCULES

SERPENS CAUDA

Great Rift

SAGITTA

Lagoon Nebula
M8

M22

SCUTUM

M11
Wild Duck Cluster

Nunki

SAGITTARIUS

DRACO

Vega

LYRA

M57
Ring Nebula

AQUILA

Altair

Dabih

α² α¹

CAPRICORNUS

MICROSCOPIUM

CYGNUS

VULPECULA

M27
Dumbbell Nebula

DELPHINUS

Deneb

EQUULEUS

GRUS

CEPHEUS

M15

Sadalmelik

AQUARIUS

PISCIS AUSTRINUS

LACERTA

PEGASUS

Water Jar

Fomalhaut

CASSIOPEIA

ANDROMEDA

Alpheratz

Great Square
of Pegasus

Circlet

Neptune

See page 18

SCULPTOR

Double
Cluster

Andromeda Galaxy
M31

ECLIPTIC

PERSEUS

NGC 752

TRIANGULUM

PISCES

CETUS

Mira

Algol

ARIES

AURIGA

Hyades

Pleiades

Aldebaran

TAURUS

September 01 00:00 BST (GMT + 1hr)
September 15 23:00 BST (GMT + 1hr)

Centre bar: Intiw of Saul

September – Looking South

The **Summer Triangle** is now high in the southwest, with the Great Square of **Pegasus** high in the southeast. Below Pegasus are the two zodiacal constellations of **Capricornus** and **Aquarius**. In what is otherwise an unremarkable constellation, α Capricorni is actually a visual binary, with the two stars (*Prima Giedi*, α¹ Cap and *Secunda Giedi*, α² Cap) readily seen with the naked eye. *Dabih* (β Capricorni), just to the south, is also a double star, and the components are relatively easy to separate with binoculars. In Aquarius, just to the east of *Sadalmelik* (α Aquarii) there is a small asterism consisting of four stars, resembling a tiny version of Cancer, known as the 'Water Jar'. Below Aquarius is a sparsely populated area of the sky with just one bright star in the constellation of **Piscis Austrinus**. In classical illustrations, water is shown flowing from the 'Water Jar' towards bright **Fomalhaut** (α Piscis Austrini).

Another zodiacal constellation, **Pisces**, is now clearly visible to the east of Aquarius. Although faint, there is a distinctive asterism of stars, known as the 'Circlet', south of the Great Square and another line of faint stars to the east of Pegasus. Still farther down towards

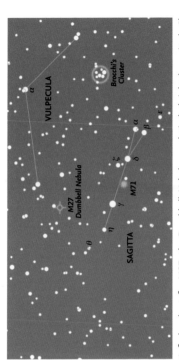

A finder chart for M27, the Dumbbell Nebula, a relatively bright (magnitude 8) planetary nebula – a shell of material ejected in the late stages of a star's lifetime – in the constellation of Vulpecula. All stars brighter than magnitude 7.5 are shown.

the horizon is the constellation of **Cetus**, with the famous variable star **Mira** (o Ceti) at its centre. When Mira is at maximum brightness (around mag. 3.5) it is clearly visible to the naked eye, but it disappears as it fades towards minimum (about mag. 9.5 or less). There is a finder chart for Mira on page 83.

The Moon's phases for September

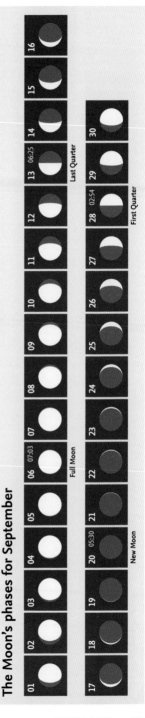

September – Moon and Planets

The Moon

Full Moon occurs on September 6, in **Aquarius**. On September 18, the waning crescent Moon (two days before New Moon), visible in the dawn sky, passes just south of Venus and very close to **Regulus** in **Leo**. (There is an occultation of the star, the start of which is visible only from part of North Africa.) On September 27, the Moon, one day before First Quarter, is visible in the early evening in the south-western sky near **Saturn** in **Ophiuchus**.

The planets

Mercury reaches greatest elongation (17.9°W) in **Leo** on September 12, in the dawn sky, when both **Mars** and **Venus** are in the vicinity. Early in the month **Venus** (magnitude -3.9) is in **Cancer**, but rapidly moves into **Leo** at the end of September. **Mars** is in the same area of Leo and at magnitude 1.8 throughout the month. It may be possible to glimpse **Jupiter** in **Virgo** very low in the evening sky early in September at magnitude -1.7, but is too low and close to the Sun to be readily visible. **Saturn** remains in **Ophiuchus** at magnitude 0.4 to 0.5, visible early in the night. **Uranus** (magnitude 5.7) is retrograding in **Pisces**, as is **Neptune** in **Aquarius**. Neptune comes to opposition on September 5 at magnitude 7.8, not far from λ Aquarii. Unfortunately Full Moon is the next day, September 6, so it is close to Neptune in the sky. The planet should be visible around a week before and after that date, however. (Charts for Uranus and Neptune are given on page 18.)

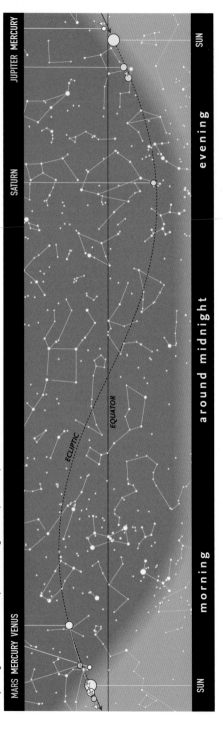

The path of the Sun and the planets along the ecliptic in September.

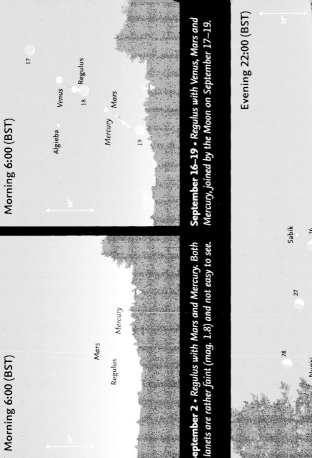

Morning 6:00 (BST)

September 16-19 • *Regulus with Venus, Mars and Mercury, joined by the Moon on September 17–19.*

Morning 6:00 (BST)

eptember 2 • Regulus with Mars and Mercury. Both lanets are rather faint (mag. 1.8) and not easy to see.

Evening 22:00 (BST)

eptember 24-28 • The Moon passes Antares, Sabik (η Oph) and Saturn. On September 28, the Moon is

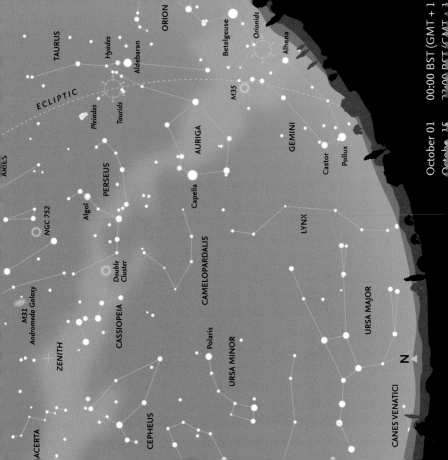

ORION

TAURUS

Hyades

Aldebaran

Betelgeuse

Orionids

Alhena

ECLIPTIC

M35

Pleiades

Taurids

AURIGA

GEMINI

ARIES

PERSEUS

Castor

Pollux

Algol

Capella

NGC 752

LYNX

Double
Cluster

CAMELOPARDALIS

M31
Andromeda Galaxy

URSA MAJOR

ZENITH

CASSIOPEIA

Polaris

URSA MINOR

N

CEPHEUS

CANES VENATICI

LACERTA

October – Looking North

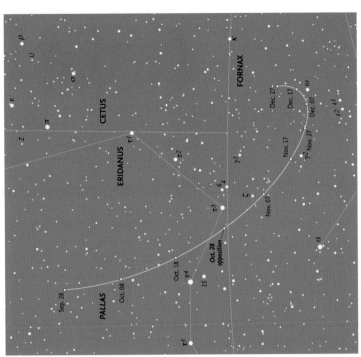

Ursa Major is grazing the horizon in the north, while high overhead are the constellations of **Cepheus**, **Cassiopeia** and **Perseus**, with the Milky Way between Cepheus and Cassiopeia at the zenith. **Auriga** is now clearly visible in the east, as is **Taurus** with the **Pleiades**, **Hyades** and orange **Aldebaran**. Also in the east, **Orion** and **Gemini** are starting to rise clear of the horizon.

The constellations of **Boötes** and **Corona Borealis** are now essentially lost to view in the northwest, and **Hercules** is also descending towards the western horizon. The three stars of the Summer Triangle are still clearly visible, although **Aquila** and **Altair** are beginning to approach the horizon in the west. Towards the end of the month (October 29) Summer Time ends in Europe with Britain reverting to Greenwich Mean Time and Europe to Central European Time.

Meteors

The **Orionids** are the major, fairly reliable meteor shower active in October. Like the May **Eta Aquarid** shower, the Orionids are associated with Comet 1P/Halley. During this second pass through the stream of particles from the comet, slightly fewer meteors are seen than in May, but conditions are more favourable for northern observers. In both showers the meteors are very fast, and many leave persistent trains. Although the Orionid maximum is quoted as October 21–22, in fact there is a very broad maximum, lasting about a week from October 20 to 27, with hourly rates around 25. Occasionally rates are higher (50–70 per hour).

The faint shower of the **Southern Taurids** (often with bright fireballs) peaks on October 23–24. Towards the end of the month, another shower (the **Northern Taurids**) begins to show activity, which peaks early in November. The parent comet for both Taurid showers is Comet 2P/Encke.

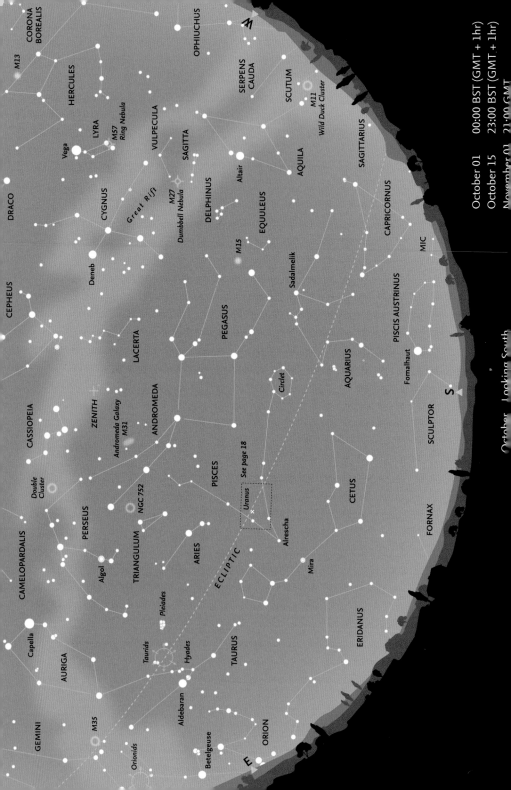

October, Looking South

October 01 00:00 BST (GMT + 1hr)
October 15 23:00 BST (GMT. + 1hr)
November 01 21:00 GMT

October – Looking South

The Great Square of **Pegasus** dominates the southern sky, framed by the two chains of stars that form the constellation of **Pisces**, together with **Alrescha** (α Piscium) at the point where the two lines of stars join. Also clearly visible is the constellation of **Cetus**, below Pegasus and Pisces. Although **Capricornus** is beginning to disappear, **Aquarius** to its east is well placed in the south, with solitary **Fomalhaut** and the constellation of **Piscis Austrinus** beneath it, close to the horizon.

The main band of the Milky Way and the Great Rift runs down from **Cygnus**, through **Vulpecula**, **Sagitta** and **Aquila** towards the western horizon. **Delphinus** and the tiny, unremarkable constellation of **Equuleus** lie between the band of the Milky Way and Pegasus. **Andromeda** is clearly visible high in the sky to the southeast, with the small constellation of **Triangulum** and the zodiacal constellation of **Aries** below it. **Perseus** is high in the east, and by now the **Pleiades** and **Taurus** are well clear of the horizon. Later in the night, and later in the month, **Orion** rises in the east, a sign that the autumn season has arrived and of the steady approach of winter.

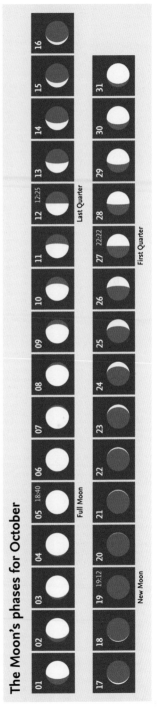

The constellation of Aquarius is one of the zodiacal constellations that is visible in late summer and early autumn. The four stars forming the 'Y'-shape of the 'Water Jar' may be seen to the east of Sadalmelik, the brightest star (top centre).

The Moon's phases for October

01	02	03	04	05 18:40	06	07	08	09	10	11	12 12:25	13	14	15	16
				Full Moon							Last Quarter				

17	18	19 19:12	20	21	22	23	24	25	26	27 22:22	28	29	30	31
		New Moon								First Quarter				

October – Moon and Planets

The Moon

On October 9, there is an occultation of *Aldebaran*, part of which may be visible from the United States. On October 15, the Moon occults *Regulus* in *Leo* and this is visible from most of the United States and parts of Canada. The waning crescent (one day before New Moon) is close to *Venus* in *Virgo* on October 18, and may just be glimpsed in the early dawn sky.

The planets

Mercury is in *Virgo* in October, but too close to the Sun to be visible. *Venus*, at magnitude -3.9 is just visible in the eastern sky early in the month, but then begins to be lost in the dawn sky. *Mars* (magnitude 1.8), moves eastwards from *Leo* into *Virgo* over the course of the month. *Jupiter* is too close to the Sun to be visible. *Saturn* (at magnitude 0.5) is slowly moving eastward in *Ophiuchus* in the southwestern sky shortly after sunset. *Uranus* comes to opposition in *Pisces* at magnitude 5.7 on October 19 and continues retrograding as shown in the chart on page 18. *Neptune*, following opposition on September 5, continues retrograde motion in *Aquarius* at magnitude 7.8 throughout the month. On October 28, dwarf planet (2) *Pallas* comes to opposition in *Eridanus* at magnitude 8.2. A finder chart is given on page 75.

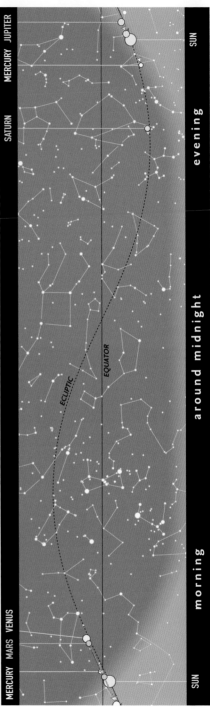

MERCURY MARS VENUS · SUN · morning · around midnight · evening · SUN · SATURN · MERCURY JUPITER

ECLIPTIC · EQUATOR

The path of the Sun and the planets along the ecliptic in October.

Calendar for October

Oct.04–Nov.14		Orionid meteor shower
05	16:14	Venus 0.2°N of Mars
05	18:40	Full Moon
08	20:54	Mercury at superior conjunction
09	05:55	Moon at perigee
09	18:05	Moon 0.6°S of Aldebaran
12	12:25	Last Quarter
15	11:19	Moon occults Regulus
17	10:05	Moon 1.8°N of Mars
18	00:21	Moon 2.1°N of Venus
19	09:38	Moon 6.9°N of Spica
19	17:35	Uranus at opposition (mag. 5.7)
19	19:12	New Moon
Oct.19–Dec.10		Northern Taurid meteor shower
21–22		Orionid shower maximum
23–24		Southern Taurid shower maximum
23	04:58	Moon 9.5°N of Antares
24	11:36	Moon 3.5°N of Saturn
25	02:26	Moon at apogee
26	18:09	Jupiter in conjunction with Sun
27	22:22	First Quarter
28	23:38	Pallas at opposition (mag. 8.2)
29		Summer Time ends (Europe)
30	20:55	Moon 0.9°S of Neptune

Evening 22:00 (BST)

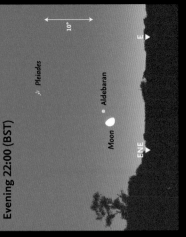

October 9 • *The Moon with Aldebaran, low above the eastern horizon. The Pleiades are a little higher.*

Morning 6:30 (BST)

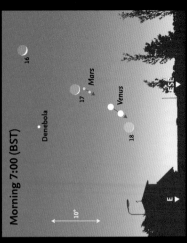

October 5–6 • *Venus and Mars are close together in the eastern sky, shortly before sunrise.*

Morning 7:00 (BST)

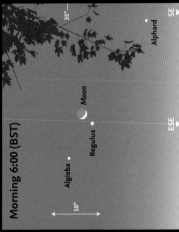

October 16–18 • *The narrow crescent Moon with Mars and Venus, in the east, shortly before sunrise.*

Morning 6:00 (BST)

October 15 • *The Moon with Regulus in the early morning. Seen from the USA, Regulus is occulted.*

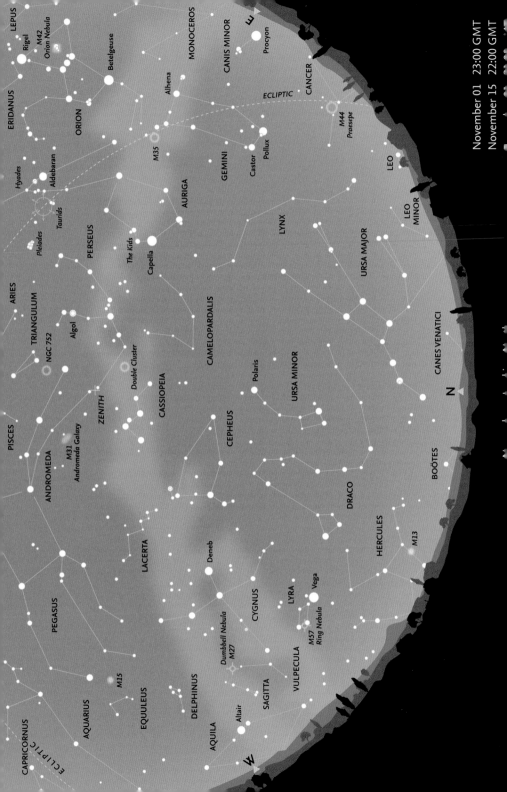

November – Looking North

A brilliant Leonid meteor, crossing the border between Pyxis and Puppis, photographed from California on 17 November 2009, during the shower maximum.

Most of **Aquila** has now disappeared below the horizon, but two of the stars of the Summer Triangle, **Vega** in **Lyra** and **Deneb** in **Cygnus**, are still clearly visible in the west. The head of **Draco** is now low in the northwest and only a small portion of **Hercules** remains above the horizon. The southernmost stars of **Ursa Major** are now coming into view. The Milky Way arches overhead, with the denser star clouds in the west and the less heavily populated region through **Auriga** and **Monoceros** in the east. High overhead, **Cassiopeia** is near the zenith and **Cepheus** has swung round to the northwest, while Auriga is now high in the northeast. **Gemini**, with **Castor** and **Pollux**, is well clear of the eastern horizon, and even **Procyon** (α Canis Minoris) is just climbing into view almost due east.

in this case watches at any time of night should detect a reasonable number of meteors.

Meteors

The **Northern Taurid** shower, which began in mid-October, reaches maximum – although with only a low rate of about five meteors per hour – on November 11–12, but gradually trails off, ending around December 10. There is an apparent 7-year periodicity in fireball activity, and 2017 is unlikely to be another peak year. Far more striking, however, are the **Leonids**, which have a short period of activity (November 5–30), with maximum on November 17–18. This shower is associated with Comet 55P/Tempel-Tuttle and has shown extraordinary activity on various occasions with many thousands of meteors per hour. High rates were seen in 1999, 2001 and 2002 (reaching about 3000 meteors per hour) but have fallen dramatically since then. The rate in 2017 is likely to be about 15 per hour. These meteors are the fastest shower meteors recorded (about 70 km per second) and often leave persistent trains. The shower is very rich in faint meteors. In 2017, maximum is on the day before and at New Moon, so conditions are particularly favourable. Observing conditions are normally best after midnight, but

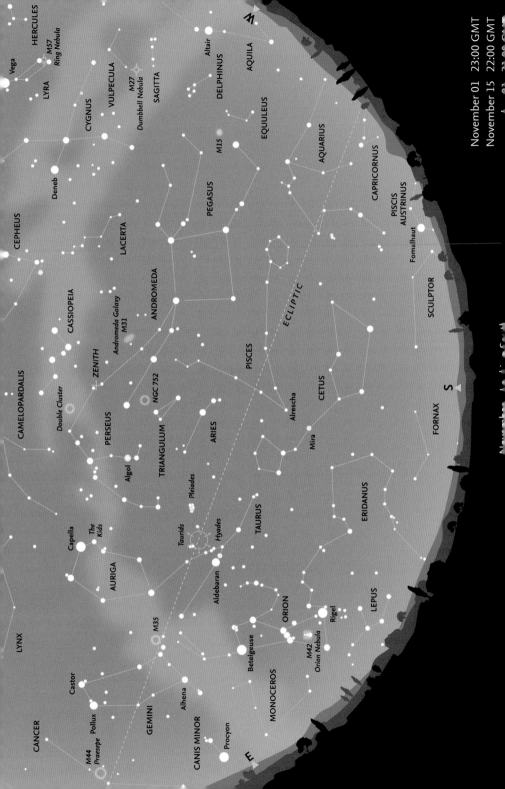

November – Looking South

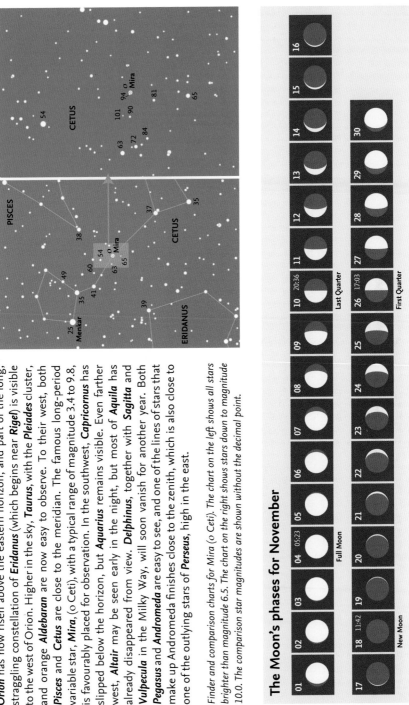

Orion has now risen above the eastern horizon, and part of the long, straggling constellation of **Eridanus** (which begins near **Rigel**) is visible to the west of Orion. Higher in the sky, **Taurus**, with the **Pleiades** cluster, and orange **Aldebaran** are now easy to observe. To their west, both **Pisces** and **Cetus** are close to the meridian. The famous long-period variable star, **Mira**, (ο Ceti), with a typical range of magnitude 3.4 to 9.8, is favourably placed for observation. In the southwest, **Capricornus** has slipped below the horizon, but **Aquarius** remains visible. Even farther west, **Altair** may be seen early in the night, but most of **Aquila** has already disappeared from view. **Delphinus**, together with **Sagitta** and **Vulpecula** in the Milky Way, will soon vanish for another year. Both **Pegasus** and **Andromeda** are easy to see, and one of the lines of stars that make up Andromeda finishes close to the zenith, which is also close to one of the outlying stars of **Perseus**, high in the east.

Finder and comparison charts for Mira (ο Ceti). The chart on the left shows all stars brighter than magnitude 6.5. The chart on the right shows stars down to magnitude 10.0. The comparison star magnitudes are shown without the decimal point.

The Moon's phases for November

November – Moon and Planets

The Moon

At Full Moon, on November 4, the Moon is in *Cetus*, close to the border of *Aries*. On November 6, there is an occultation of *Aldebaran*, the start of which is technically visible with difficulty from the southern United States. On November 15, the Moon is close to *Mars* in the pre-dawn eastern sky. The maximum of the Leonid meteor shower, November 17–18, occurs just before New Moon (on November 18). On November 21, the Moon is at apogee, at 406,602 km (when it is at its greatest distance from Earth in 2017). On November 21 it is 1.3° south of *Regulus* in *Leo*. On November 25–26, shortly before First Quarter, it is in the vicinity of *Jupiter* and *Spica* in *Virgo*.

The planets

Mercury reaches greatest eastern elongation on November 23 in *Ophiuchus* but is too low to be visible during the month. On November 2, *Venus* is visible at magnitude -3.9 in the early morning, close to *Spica* in *Virgo*. *Mars*, also in Virgo, brightens slightly from magnitude 1.8 to 1.7 over the month. *Jupiter* is in the same area of sky, initially visible in the early morning sky, at magnitude -1.7, moving slowly eastwards. *Saturn* is still in *Ophiuchus*, and may initially be glimpsed in the evening sky, but soon becomes low and close to the Sun. *Uranus* is still retrograding in *Pisces* at magnitude 5.7 and *Neptune* in *Aquarius* at magnitude 7.9 retrogrades very slowly until it reaches a stationary point (on November 22).

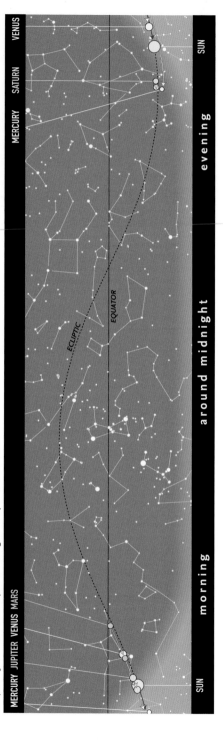

The path of the Sun and the planets along the ecliptic in November.

Calendar for November

02	13:58	Venus 3.5°N of Spica
03	00:31	Moon 4.2°S of Uranus
04	05:23	Full Moon
05–30		Leonid meteor shower
05		Daylight Saving Time ends (N. America)
06	00:10	Moon at perigee
06	02:19	Moon 0.7°N of Aldebaran
10	20:36	Last Quarter
11–12		Northern Taurid shower maximum
11	16:32	Moon 0.5°S of Regulus
15	00:40	Moon 3.4°N of Mars
15	16:00	Moon 7.0°N of Spica
15	21:26	Moon 4.1°N of Jupiter
17–18		Leonid shower maximum
17	05:39	Moon 4.0°N of Venus
18	11:42	New Moon
21	00:17	Moon 3.0°N of Saturn
21	18:53	Moon at apogee
24	00:27	Mercury greatest elongation (22.0°E, mag. -0.4)
26	17:03	First Quarter
26	05:18	Moon 1.2°S of Neptune
29	14:27	Mars 3.1°N of Spica
29	09:36	Moon 4.3°S of Uranus

Morning 6:30

November 2 • Venus with Mars and Spica in the east-southeast, shortly before sunrise.

After midnight 2:00

November 6 • The Moon is close to Aldebaran, with the Pleiades nearby.

Morning 7:00

November 15–17 • The narrow crescent moon passes Mars, Spica, Jupiter and Venus, before sunrise in the southeast.

Morning 6:30

November 29 • Jupiter, Mars and Spica in the early morning sky.

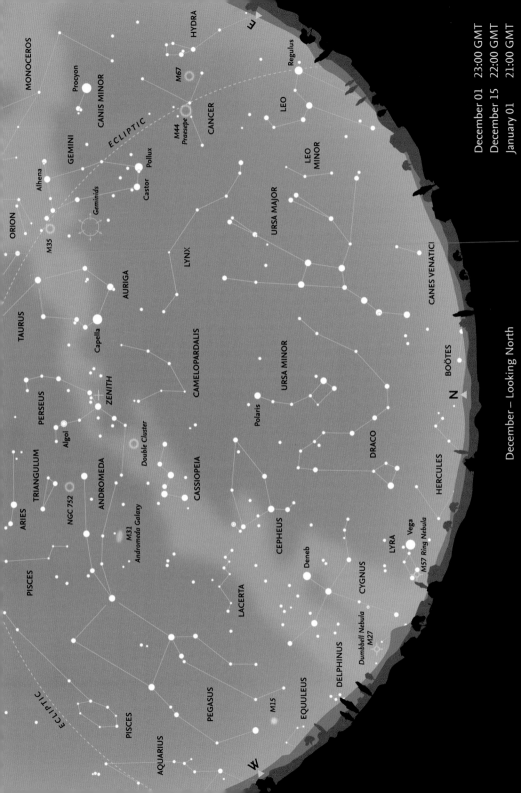

December 01 23:00 GMT
December 15 22:00 GMT
January 01 21:00 GMT

December – Looking North

December – Looking North

Ursa Major has now swung round and is starting to 'climb' in the east. The fainter stars in the southern part of the constellation are now fully in view. The other bear, *Ursa Minor*, 'hangs' below *Polaris* in the north. Directly above it is the faint constellation of *Camelopardalis*, with the other inconspicuous circumpolar constellation, *Lynx*, to its east. *Vega* (α Lyrae) is skimming the horizon in the northwest, but *Deneb* (α Cygni) and most of *Cygnus* remain visible farther west. In the east, *Regulus* (α Leonis) and the constellation of *Leo* are beginning to rise above the horizon. *Cancer* stands high in the east, with *Gemini* even higher in the sky. *Perseus* is at the zenith, with *Auriga* and *Capella* between it and Gemini. Because it is so high in the sky, now is a good time to examine the star clouds of the fainter portion of the Milky Way, between *Cassiopeia* in the west to Gemini and *Orion* in the east.

Meteors

There is one significant meteor shower in December (the last major shower of the year). This is the *Geminid* shower, which is visible over the period December 4–16 and comes to maximum on December 13–14 with a waning crescent Moon. It is one of the most active showers of the year, and in some years is the most active, with a peak rate of around 100 meteors per hour. It is the one major shower that shows good activity before midnight. The meteors have been found to have a much higher density than other meteors (which are derived from cometary material). It was eventually established that the Geminids and the asteroid Phaethon had similar orbits. So the Geminids are assumed to consist of denser, rocky material. They are slower than most other meteors and often appear to last longer. The brightest often break up into numerous luminous fragments that follow similar paths across the sky. There is a second shower: the *Ursids*, active December 17–23, peaking on December 21–22, with rate at maximum of 5–10, occasionally rising to 25 per hour. Maximum in 2017 is when the Moon is just three and four days old, so conditions are favourable. The parent body is Comet 8P/Tuttle.

The constellation of Orion dominates the sky during this period of the year, and is a useful starting point for recognizing other constellations in the southern sky. Here, orange Betelgeuse, blue-white Rigel and the pinkish Orion Nebula are prominent. Orion can be found in the southern part of the sky (see next page).

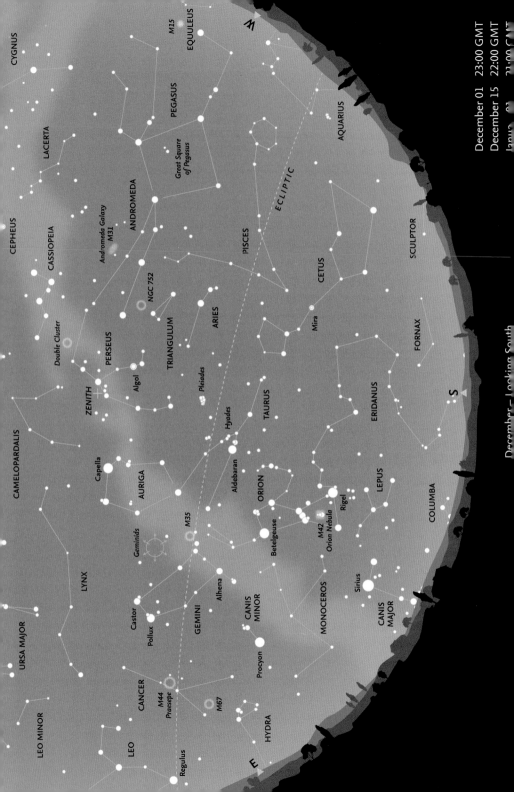

December 01 23:00 GMT
December 15 22:00 GMT

December– Looking South

December – Looking South

The fine open cluster of the *Pleiades* is due south around 22:00, with the *Hyades* cluster, *Aldebaran* and the rest of *Taurus* clearly visible to the east. *Auriga* (with *Capella*) and *Gemini* (with *Castor* and *Pollux*) are both well-placed for observation. *Orion* has made a welcome return to the winter sky, and both *Canis Minor* (with *Procyon*) and *Canis Major* (with *Sirius*, the brightest star in the sky) are now well above the horizon. The small, poorly known constellation of *Lepus* lies to the south of Orion. In the west, *Aquarius* has now disappeared, and *Cetus* is becoming lower, but *Pisces* is still easily seen, as are the constellations of *Aries*, *Triangulum* and *Andromeda* above it. The Great Square of *Pegasus* is starting to plunge down towards the western horizon, and because of its orientation on the sky appears more like a large diamond, standing on one point, than a square.

The constellation of Taurus contains two contrasting open clusters: the compact Pleiades, with its striking blue-white stars, and the more scattered, but much closer, 'V'-shaped Hyades. Orange Aldebaran (α Tauri) is not related to the Hyades, but lies between it and the Earth.

The Moon's phases for December

| 01 | 02 | 03 15:47 | 04 | 05 | 06 | 07 | 08 | 09 | 10 07:51 | 11 | 12 | 13 | 14 | 15 | 16 |
| | | Full Moon | | | | | | | Last Quarter | | | | | | |

| 17 | 18 06:30 | 19 | 20 | 21 | 22 | 23 | 24 | 25 | 26 09:20 | 27 | 28 | 29 | 30 | 31 |
| | New Moon | | | | | | | | First Quarter | | | | | |

December – Moon and Planets

The Moon

On December 3, the Full Moon is close to *Aldebaran* in *Taurus*. There is an occultation of the star, visible from Asia and Alaska. On December 8, the Moon passes 0.7°S of *Regulus* (α Leonis). Again, there is an occultation, but visible only from eastern Europe and north-western Asia. On December 13 to 15, the waning crescent Moon passes *Mars* in *Virgo* and *Jupiter* in *Libra*. On December 31, the Moon, approaching Full, again occults *Aldebaran*, but as with the occultation of Regulus, this is visible only from eastern Europe and north-western Asia.

The planets

Mercury is close to the Sun and passes inferior conjunction on December 13. Early in the month it may be possible to glimpse *Venus* low in the dawn sky at magnitude -3.9, but it soon becomes very close to the Sun. Initially in *Libra*, near the border of *Scorpius*, it moves into *Sagittarius* by the end of the month. *Mars* begins the month in *Virgo*, close to *Spica*, at magnitude 1.7, but continues to move eastward and ends the month in *Libra*, near *Zubenelgenubi* (α Librae), brightening slightly to mag. 1.5. *Jupiter* (magnitude -1.7 to -1.8) is also near Zubenelgenubi moving slowly eastwards. *Saturn* (magnitude 0.4–0.5) is in *Sagittarius*, where it has been for the whole year. *Uranus*, at magnitude 5.7–5.8, continues to retrograde slowly in *Pisces*. *Neptune* (magnitude 7.9), after reaching a stationary point on November 23, begins direct motion in *Aquarius*.

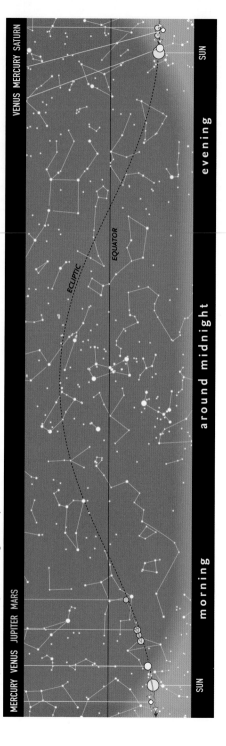

The path of the Sun and the planets along the ecliptic in December.

MERCURY VENUS JUPITER MARS

VENUS MERCURY SATURN

SUN

morning

around midnight

evening

SUN

ECLIPTIC

EQUATOR

Calendar for December

03	13:00	Aldebaran 0.8°N of Moon
03	15:47	Full Moon
04	08:46	Moon at perigee
04–16		Geminid meteor shower
08	22:25	Moon 0.7°S of Regulus
10	07:51	Last Quarter
12	21:26	Moon 7.2°N of Spica
13–14		Geminid shower maximum
13	01:48	Mercury at inferior conjunction
13	16:28	Moon 4.2°N of Mars
14	14:26	Moon 4.7°N of Jupiter
16	18:18	Moon 9.4°N of Antares
17–23		Ursid meteor shower
17	17:54	Moon 4.1°N of Venus
18	06:30	New Moon
18	13:09	Moon 2.8°N of Saturn
19	01:26	Moon at apogee (Greatest of year, 406,602 km)
21	16:28	Winter solstice
21	21:08	Saturn in conjunction with Sun
21–22		Ursid shower maximum
24	12:39	Moon 1.4°S of Neptune
26	09:20	First Quarter
27	18:02	Moon 4.5°S of Uranus
31	00:49	Moon 0.8°N of Aldebaran

Evening 20:00

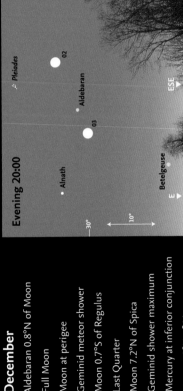

December 2–3 • *The Moon passes the Pleiades and Aldebaran. Betelgeuse and Alnath (β Tauri) are also nearby.*

Morning 7:30

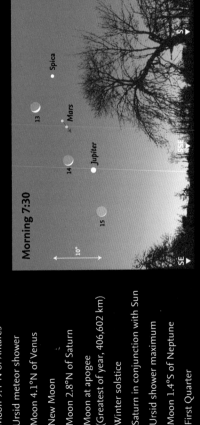

December 13–15 • *The Moon passes Spica, Mars and Jupiter, before sunrise in the southeastern sky.*

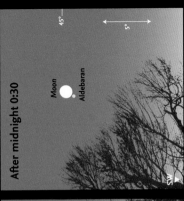

Evening 23:30

December 8 • *The Moon is close to Regulus, low in the eastern sky.*

After midnight 0:30

December 31 • *The Moon is close to Aldebaran.*

Glossary and Tables

aphelion	The point on an orbit that is farthest from the Sun.
apogee	The point on its orbit at which the Moon is farthest from the Earth.
appulse	The apparently close approach of two celestial objects; two planets, or a planet and star.
astronomical unit	(AU) The mean distance of the Earth from the Sun, 149,597,870 km.
celestial equator	The great circle on the celestial sphere that is in the same plane as the Earth's equator.
celestial sphere	The apparent sphere surrounding the Earth on which all celestial bodies (stars, planets, etc.) seem to be located.
conjunction	The point in time when two celestial objects have the same celestial longitude. In the case of the Sun and a planet, superior conjunction occurs when the planet lies on the far side of the Sun (as seen from Earth). For Mercury and Venus, inferior conjuction occurs when they pass between the Sun and the Earth.
direct motion	Motion from west to east on the sky.
ecliptic	The apparent path of the Sun across the sky throughout the year. Also: the plane of the Earth's orbit in space.
elongation	The point at which an inferior planet has the greatest angular distance from the Sun, as seen from Earth.
equinox	The two points during the year when night and day have equal duration. Also: the points on the sky at which the ecliptic intersects the celestial equator. The vernal (spring) equinox is of particular importance in astronomy.
gibbous	The stage in the sequence of phases at which the illumination of a body lies between half and full. In the case of the Moon, the term is applied to phases between First Quarter and Full, and between Full and Last Quarter.
inferior planet	Either of the planets Mercury or Venus, which have orbits inside that of the Earth.
magnitude	The brightness of a star, planet or other celestial body. It is a logarithmic scale, where larger numbers indicate fainter brightness. A difference of 5 in magnitude indicates a difference of 100 in actual brightness, thus a first-magnitude star is 100 times as bright as one of sixth magnitude.
meridian	The great circle passing through the North and South Poles of a body and the observer's position; or the corresponding great circle on the celestial sphere that passes through the North and South Celestial Poles and also through the observer's zenith.
nadir	The point on the celestial sphere directly beneath the observer's feet, opposite the zenith.
occultation	The disappearance of one celestial body behind another, such as when stars or planets are hidden behind the Moon.
opposition	The point on a superior planet's orbit at which it is directly opposite the Sun in the sky.
perigee	The point on its orbit at which the Moon is closest to the Earth.
perihelion	The point on an orbit that is closest to the Sun.
retrograde motion	Motion from east to west on the sky.
superior planet	A planet that has an orbit outside that of the Earth.
vernal equinox	The point at which the Sun, in its apparent motion along the ecliptic, crosses the celestial equator from south to north. Also known as the First Point of Aries.
zenith	The point directly above the observer's head.
zodiac	A band, stretching 8° on either side of the ecliptic, within which the Moon and planets appear to move. It consists of twelve equal areas, originally named after the constellation that once lay within it.

The Greek Alphabet

| | | | | | | | | | | | | | | |
|---|---|---|---|---|---|---|---|---|---|---|---|---|---|---|---|
| α | Alpha | ε | Epsilon | ι | Iota | ν | Nu | ρ | Rho | φ (φ) | Phi |
| β | Beta | ζ | Zeta | κ | Kappa | ξ | Xi | σ (ς) | Sigma | χ | Chi |
| γ | Gamma | η | Eta | λ | Lambda | ο | Omicron | τ | Tau | ψ | Psi |
| δ | Delta | θ (ϑ) | Theta | μ | Mu | π | Pi | υ | Upsilon | ω | Omega |

The Constellations

There are 88 constellations covering the whole of the celestial sphere, but 24 of these in the southern hemisphere can never be seen (even in part) from the latitude of Britain and Ireland, so are omitted from this table. The names themselves are expressed in Latin, and the names of stars are frequently given by Greek letters followed by the genitive of the constellation name. The genitives and English names of the various constellations are included.

Name	Genitive	Abbr.	English name
Andromeda	Andromeda	And	Andromeda
Antlia	Antliae	Ant	Air Pump
Aquarius	Aquarii	Aqr	Water Bearer
Aquila	Aquilae	Aql	Eagle
Aries	Arietis	Ari	Ram
Auriga	Aurigae	Aur	Charioteer
Boötes	Boötis	Boo	Herdsman
Camelopardalis	Camelopardalis	Cam	Giraffe
Cancer	Cancri	Cnc	Crab
Canes Venatici	Canum Venaticorum	CVn	Hunting Dogs
Canis Major	Canis Majoris	CMa	Big Dog
Canis Minor	Canis Minoris	CMi	Little Dog
Capricornus	Capricorni	Cap	Sea Goat
Cassiopeia	Cassiopeiae	Cas	Cassiopeia
Centaurus	Centauri	Cen	Centaur
Cepheus	Cephei	Cep	Cepheus
Cetus	Ceti	Cet	Whale
Columba	Columbae	Col	Dove
Coma Berenices	Comae Berenices	Com	Berenice's Hair
Corona Australis	Coronae Australis	CrA	Southern Crown
Corona Borealis	Coronae Borealis	CrB	Northern Crown
Corvus	Corvi	Crv	Crow
Crater	Crateris	Crt	Cup
Cygnus	Cygni	Cyg	Swan
Delphinus	Delphini	Del	Dolphin
Draco	Draconis	Dra	Dragon
Equuleus	Equulei	Equ	Little Horse
Eridanus	Eridani	Eri	River Eridanus
Fornax	Fornacis	For	Furnace
Gemini	Geminorum	Gem	Twins
Hercules	Herculis	Her	Hercules
Hydra	Hydrae	Hya	Water Snake

Name	Genitive	Abbr.	English name
Lacerta	Lacertae	Lac	Lizard
Leo	Leonis	Leo	Lion
Leo Minor	Leonis Minoris	LMi	Little Lion
Lepus	Leporis	Lep	Hare
Libra	Librae	Lib	Scales
Lupus	Lupi	Lup	Wolf
Lynx	Lyncis	Lyn	Lynx
Lyra	Lyrae	Lyr	Lyre
Microscopium	Microscopii	Mic	Microscope
Monoceros	Monocerotis	Mon	Unicorn
Ophiuchus	Ophiuchi	Oph	Serpent Bearer
Orion	Orionis	Ori	Orion
Pegasus	Pegasi	Peg	Pegasus
Perseus	Persei	Per	Perseus
Pisces	Piscium	Psc	Fishes
Piscis Austrinus	Piscis Austrini	PsA	Southern Fish
Puppis	Puppis	Pup	Stern
Pyxis	Pyxidis	Pyx	Compass
Sagitta	Sagittae	Sge	Arrow
Sagittarius	Sagittarii	Sgr	Archer
Scorpius	Scorpii	Sco	Scorpion
Sculptor	Sculptoris	Scl	Sculptor
Scutum	Scuti	Sct	Shield
Serpens	Serpentis	Ser	Serpent
Sextans	Sextantis	Sex	Sextant
Taurus	Tauri	Tau	Bull
Triangulum	Trianguli	Tri	Triangle
Ursa Major	Ursae Majoris	UMa	Great Bear
Ursa Minor	Ursae Minoris	UMi	Lesser Bear
Vela	Velorum	Vel	Sails
Virgo	Virginis	Vir	Virgin
Vulpecula	Vulpeculae	Vul	Fox

Some common asterisms

Belt of Orion	δ, ε, and ζ Orionis
Big Dipper	α, β, γ, δ, ε, ζ, and η Ursae Majoris
Circlet	γ, θ, ι, λ, and κ Piscium
Guards (or Guardians)	β and γ Ursae Minoris
Head of Cetus	α, γ, ξ², μ, and λ Ceti
Head of Draco	β, γ, ξ, and ν Draconis
Head of Hydra	δ, ε, ζ, η, ρ, and σ Hydrae
Keystone	ε, ζ, η, and π Herculis
Kids	ε, ζ, and η Aurigae
Little Dipper	β, γ, η, ζ, ε, δ, and α Ursae Minoris
Lozenge	= Head of Draco
Milk Dipper	ζ, γ, σ, φ, and λ Sagittarii
Plough or Big Dipper	α, β, γ, δ, ε, ζ, and η Ursae Majoris
Pointers	α and β Ursae Majoris
Sickle	α, η, γ, ζ, μ, and ε Leonis
Square of Pegasus	α, β, and γ Pegasi with α Andromedae
Sword of Orion	θ and ι Orionis
Teapot	γ, ε, δ, λ, φ, σ, τ, and ζ Sagittarii
Wain (or Charles' Wain)	= Plough
Water Jar	γ, η, κ, and ζ Aquarii
Y of Aquarius	= Water Jar

Acknowledgements

peresanz/Shutterstock: p.87 (Orion)

Steve Edberg, La Cañada, California: all other constellation photographs

NASA/ESA/STScI: p.57 (Pluto)

Ken Sperber, California: p.69 (Double Cluster)

Navicore: p.81 (Leonid meteor)

Editorial support was provided by Edward Bloomer, Astronomer at the Royal Observatory, Greenwich, part of Royal Museums Greenwich.

Further Information

Books

Bone, Neil (1993), *Observer's Handbook: Meteors*, George Philip, London & Sky Publ. Corp., Cambridge, Mass.

Cook, J., ed. (1999), *The Hatfield Photographic Lunar Atlas*, Springer-Verlag, New York

Dunlop, Storm (1999), *Wild Guide to the Night Sky*, HarperCollins, London

Dunlop, Storm (2012), *Practical Astronomy*, 3rd edn, Philip's, London

Dunlop, Storm, Rükl, Antonin & Tirion, Wil (2005), *Collins Atlas of the Night Sky*, HarperCollins, London

O'Meara, Stephen J. (2008), *Observing the Night Sky with Binoculars*, Cambridge University Press, Cambridge

Ridpath, Ian, ed. (2004), *Norton's Star Atlas*, 20th edn, Pi Press, New York

Ridpath, Ian, ed. (2003), *Oxford Dictionary of Astronomy*, 2nd edn, Oxford University Press, Oxford

Ridpath, Ian & Tirion, Wil (2004), *Collins Gem - Stars*, HarperCollins, London

Ridpath, Ian & Tirion, Wil (2011), *Collins Pocket Guide Stars and Planets*, 4th edn, HarperCollins, London

Ridpath, Ian & Tirion, Wil (2012), *Monthly Sky Guide*, 9th edn, Cambridge University Press

Rükl, Antonín (1990), *Hamlyn Atlas of the Moon*, Hamlyn, London & Astro Media Inc., Milwaukee

Rükl, Antonín (2004), *Atlas of the Moon*, Sky Publishing Corp., Cambridge, Mass.

Scagell, Robin (2000), *Philip's Stargazing with a Telescope*, George Philip, London

Tirion, Wil (2011), *Cambridge Star Atlas*, 4th edn, Cambridge University Press, Cambridge

Tirion, Wil & Sinnott, Roger (1999), *Sky Atlas 2000.0*, 2nd edn, Sky Publishing Corp., Cambridge, Mass. & Cambridge University Press, Cambridge

Journals

Astronomy, Astro Media Corp., 21027 Crossroads Circle, P.O. Box 1612, Waukesha, WI 53187-1612 USA. http://www.astronomy.com

Astronomy Now, Pole Star Publications, PO Box 175, Tonbridge, Kent TN10 4QX UK. http://www.astronomynow.com

Sky at Night Magazine, BBC publications, London. http://skyatnightmagazine.com

Sky & Telescope, Sky Publishing Corp., Cambridge, MA 02138-1200 USA. http://www.skyandtelescope.com/

Societies

British Astronomical Association, Burlington House, Piccadilly, London W1J 0DU. http://www.britastro.org/

The principal British organization for amateur astronomers (with some professional members), particularly for those interested in carrying out observational programmes. Its membership is, however, worldwide. It publishes fully refereed, scientific papers and other material in its well-regarded journal.

Federation of Astronomical Societies, Secretary: Ken Sheldon, Whitehaven, Maytree Road, Lower Moor, Pershore, Worcs. WR10 2NY. http://www.fedastro.org.uk/fas/

An organization that is able to provide contact information for local astronomical societies in the United Kingdom.

Royal Astronomical Society, Burlington House, Piccadilly, London W1J 0BQ. http://www.ras.org.uk/

The premier astronomical society, with membership primarily drawn from professionals and experienced amateurs. It has an exceptional library and is a designated centre for the retention of certain classes of astronomical data. Its publications are the standard medium for dissemination of astronomical research.

Society for Popular Astronomy, 36 Fairway, Keyworth, Nottingham NG12 5DU.

http://www.popastro.com/

A society for astronomical beginners of all ages, which concentrates on increasing members' understanding and enjoyment, but which does have some observational programmes. Its journal is entitled *Popular Astronomy*.

Software

Planetary, Stellar and Lunar Visibility, (Planetary and eclipse freeware): Alcyone Software, Germany.
http://www.alcyone.de

Redshift, Redshift-Live. http://www.redshift-live.com/en/

Starry Night & Starry Night Pro, Sienna Software Inc., Toronto, Canada. http://www.starrynight.com

Internet sources

There are numerous sites with information about all aspects of astronomy, and all of those have numerous links. Although many amateur sites are excellent, treat any statements and data with caution. The sites listed below offer accurate information. Please note that the URLs may change. If so, use a good search engine, such as Google, to locate the information source.

Information

Astronomical data (inc. eclipses) HM Nautical Almanac Office: http://astro.ukho.gov.uk

Auroral information Michigan Tech: http://www.geo.mtu.edu/weather/aurora/

Comets JPL Solar System Dynamics: http://ssd.jpl.nasa.gov/

American Meteor Society: http://amsmeteors.org/

Deep-sky objects Saguaro Astronomy Club Database: http://www.virtualcolony.com/sac/

Eclipses: NASA Eclipse Page: http://eclipse.gsfc.nasa.gov/eclipse.html

Moon (inc. Atlas) Inconstant Moon: http://www.inconstantmoon.com/

Planets Planetary Fact Sheets: http://nssdc.gsfc.nasa.gov/planetary/planetfact.html

Satellites (inc. International Space Station)

Heavens Above: http://www.heavens-above.com/

Visual Satellite Observer: http://www.satobs.org/

Star Chart National Geographic Chart:

http://www.nationalgeographic.com/features/97/stars/chart/index.html

What's Visible Skyhound: http://www.skyhound.com/sh/skyhound.html

Skyview Cafe: http://www.skyviewcafe.com

Stargazer: http://www.outerbody.com/stargazer/ (choose 'File, New View', click & drag to change)

Institutes and Organizations

European Space Agency: http://www.esa.int/

International Dark-Sky Association: http://www.darksky.org/

Jet Propulsion Laboratory: http://www.jpl.nasa.gov/

Lunar and Planetary Institute: http://www.lpi.usra.edu/

National Aeronautics and Space Administration: http://www.hq.nasa.gov/

Solar Data Analysis Center: http://umbra.gsfc.nasa.gov/

Space Telescope Science Institute: http://www.stsci.edu/